ALBERTA RHYTHM

Vista from Teshierpi Mountains, August 1950.

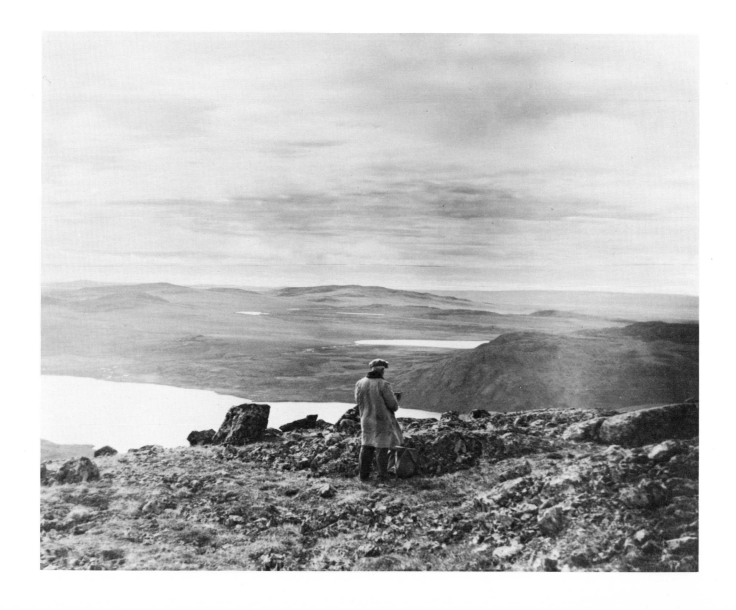

Dennis Reid

ALBERTA RHYTHM

THE LATER WORK OF A.Y. JACKSON

ART GALLERY OF ONTARIO/MUSÉE DES BEAUX-ARTS DE L'ONTARIO

TORONTO/CANADA

The Art Gallery of Ontario gratefully acknowledges the support of Costain Limited.

COVER:

No. 39
Alberta Rhythm 1948
Oil on canvas, 53.7 x 66.4 cm
Private collection

Canadian Cataloguing in Publication Data

Reid, Dennis.
 Alberta rhythm

(The Later works of the Group of Seven)
Catalogue of an exhibition held at the Art Gallery of Ontario, May 14-June 27, 1982, and at the Glenbow Museum, 1982.
Bibliography: p.
ISBN 0-919876-87-0

1. Jackson, A.Y. (Alexander Young), 1882-1974 – Exhibitions. I. Jackson, A.Y. (Alexander Young), 1882-1974. II. Art Gallery of Ontario. III. Glenbow Museum. IV. Title. V. Series.

ND249.J3A4 1982 759.11 C82-094381-9

The Art Gallery of Ontario is funded by the Province of Ontario, the Ministry of Citizenship and Culture, the Municipality of Metropolitan Toronto, and the Government of Canada through the National Museums Corporation and the Canada Council.

PHOTO CREDITS

PLATES:

James A. Chambers: 4, 6, 8; Jim Gorman/Vancouver Art Gallery: 3; Robert Keziere: 1; Larry Ostrom/Art Gallery of Ontario: cover, 2, 5; Trevor Mills/Art Gallery of Greater Victoria: 7.

CATALOGUE:

Art Gallery of Greater Victoria: 47, 64, 72, 73; James Chambers: 25, 51; John Evans Photography Ltd.: 5, 65, 67, 68, 69, 70, 71, 74, 75, 76, 77, 80, 81; Stephen Evans and Larry Ostrom/Art Gallery of Ontario: 1, 7, 9, 10, 12, 17, 19, 23, 24, 27, 32, 36, 38, 39, 46, 48, 50, 52, 53, 54, 55, 56, 57, 58, 61, 78, 79; Glenbow Museum: 35; Jim Gorman/Vancouver Art Gallery: 33, 60; Eleanor Lazare: 34, 40; Ron Marsh/Glenbow Museum: 6, 26, 62, 63; McMichael Canadian Collection, Kleinburg: 2, 3, 11, 13, 21, 22; Brian Merrett, Montreal: 18, 28, 41, 42, 66; The National Gallery of Canada, Ottawa: 4, 15, 16, 20, 30, 31, 44, 49, 59; Michael Neill: 45; Rosalyn Porter, Vancouver: 14, 37; Saltmarche Bros.: 8, 29, 43.

ADDITIONAL PHOTOGRAPHY:

Art Gallery of Hamilton, p. 28; Geneva Jackson Baird, p. 34; B.S.W. Buffan, p. 97; Mrs. Freda Bundy, p. 93; Frank A. Halliday, Calgary, p. 97; Dr. Maurice Haycock, Ottawa, p. 2; Ira Mann, Sault Ste. Marie, p. 96; National Film Board and Public Archives of Canada, photo: Jack Long, p. 95; Weekend Magazine Staff Photo, p. 52.

GRAPHIC DESIGN: Frank Newfeld
TYPESETTING: Trigraph
PRINTING: Bryant Press
BINDING: Bryant Press

ITINERARY OF THE EXHIBITION:
Art Gallery of Ontario, Toronto, May 15 - June 27, 1982
Glenbow Museum, Calgary, July 16 - September 5, 1982

Contents

Foreword

For a nation that is barely 120 years old, Canada enjoys an impressive cultural heritage that typifies the spirit and geography of the country. The Group of Seven is a vital component of this heritage and did much to establish a name for Canadian art. Its members exhibited, as a group, in the early part of the twentieth century and, during the following years, spent time diversifying and expanding their individual artistic talents.

It was during this later period that A.Y. Jackson, one of the Group's leading members, shifted his interest to Alberta and the Northwest from central Canada – Ontario and Quebec. It is these works that for the first time have been assembled and catalogued.

The realization that there still is much to discover in Canada's cultural legacy is a challenge and inspiration. Costain Limited, a Canadian real estate development company with operations throughout North America, is pleased to be a part of the production of this historically important exhibition.

G.L. Duff
President and Chief Executive Officer
Costain Limited

Preface

The Group of Seven, their lives, their artistic careers are so familiar a part of Canadian history that many exhibitions make us feel we know more about these seven men and their work than, in fact, we do. Dennis Reid, the Curator of Canadian Historical Art, has chosen to mount a series of exhibitions, of which this is the first, that will surprise and challenge viewers, by examining the late work of major figures of the Group. The interested gallery-goer and student of Canadian art will have an opportunity to see several members of the Group in this new way, free of deadening familiarity and legend.

In *Alberta Rhythm: The Later Work of A. Y. Jackson*, we are invited to look at mature work that has been long assumed to be less satisfactory than that of Jackson's earlier years. Thanks to Mr. Reid, these paintings now can be seen in a new context and more realistically appreciated as the work of an artist who, unwilling to languish as a myth, never stopped challenging himself and his talent.

The Group of Seven is, of course, historically linked to the Art Gallery of Ontario: The first of the Group's shows was held at the then Art Gallery of Toronto in May 1920, and each of the seven subsequent Group shows was held here; in the 1920s they were an almost annual event. The first retrospectives of Group members Harris, Lismer, Varley, and Jackson were presented at the Art Gallery of Toronto.

It is fitting that Mr. Reid should have chosen to begin his series with A.Y. Jackson. Throughout his life, his work, and his writing, Jackson most closely adhered to the ideals of the Group of Seven. Moreover, this city and this Gallery have been the beneficiaries of his interest and involvement from the Group's earliest days. After the Group broke up, Dr. Jackson was instrumental in arranging for the initial Art Gallery of Toronto showing of the newly formed Canadian Group of Painters; and he was actively involved with the Gallery's Exhibitions and Collections Committees from 1933 to 1955.

Today, years after his death, A.Y. Jackson remains the most Canadian of all our artists, an almost mythic figure for the art historian as well as the casual art lover. An unabashed democrat, Jackson always wanted the general public as his audience. While this public will find Mr. Reid's appreciation of Dr. Jackson both thorough and sympathetic, scholars and collectors will be able to use the text to situate specific works in the artist's career. The detailed documentation and exceptionally precise chronology of Dr. Jackson's travels will be of particular interest to historians. In sum, general reader and specialist alike are in Mr. Reid's debt for the exhibition and its catalogue, impeccably researched and thoughtfully written.

Finally, the Gallery acknowledges with pleasure its debt to the lenders, both private and corporate. We thank them for their generosity, which has made it possible for many Canadians to share in the pleasure of this handsome and important exhibition.

William J. Withrow
Director
Art Gallery of Ontario

Lenders to the Exhibition

Sally Stewart Douglas, *Toronto*

Bram Garber, *Montreal*

Kenneth G. Heffel Fine Art Inc., *Vancouver*

Kaspar Gallery, *Toronto*

Lethbridge Community College, *Lethbridge, Alberta*

Mr. and Mrs. Robert McMichael, *Kleinburg, Ontario*

Mr. and Mrs. N.D. Young, *Toronto*

and other private collectors

Art Gallery of Greater Victoria

Art Gallery of Ontario, *Toronto*

The Edmonton Art Gallery

Glenbow Museum, *Calgary*

The McMichael Canadian Collection, *Kleinburg, Ontario*

The National Gallery of Canada, *Ottawa*

Ontario Heritage Foundation,
Firestone Art Collection, *Ottawa*

Vancouver Art Gallery

Acknowledgements

Virtually every member of the staff of the Art Gallery of Ontario contributes to the production and staging of an exhibition and its accompanying catalogue. In this instance, the following people have had specific responsibilities, and have fulfilled them with economy and yet with a professional attention to detail: Barry Simpson, Manager of Curatorial Administration; Marie DunSeith, Development Manager; Maia-Mari Sutnik, Coordinator of Photographic Services; Larry Ostrom, Chief Photographer; Ed Zukowski, Conservator; Denise Bukowski, Head of Publications, and her staff; Eva Robinson, Registrar, and her staff, particularly Kathy Wladyka, Assistant Registrar; Ches Taylor, Manager of Technical Services; John Ruseckas, Chief Preparator, and his staff. It has been a pleasure to work with Charis Wahl, as editor, and with Frank Newfeld, who designed this publication.

The development of the exhibition from concept to the walls of the gallery, and the creation of a catalogue of some substance, have been the result of a direct collaboration among four people. It began with my close association over many years with Naomi Jackson Groves, a strong scholar in a number of areas, including the life and work of her uncle, A.Y. Jackson. Carol Lowrey, Technical Services Librarian in the Reference Library of the Art Gallery, joined the team shortly after the exhibition was scheduled. My secretary, Edie Sersta, has coordinated the whole project. That it has finally flowed together so smoothly is a tribute to her efficiency.

Dennis Reid
Curator of Canadian Historical Art

FIG. 1 In the studio, Studio Building, Toronto, c. 1940.

The Later Work of A.Y. Jackson

This study is a description of both the work and the way of working of A.Y. Jackson during the second half of his career. It is the first ever undertaken, even though Jackson, born a century ago, was in his lifetime the most widely appreciated of Canadian artists, and is generally acknowledged to have contributed substantially to the development of painting in Canada. Because the Group of Seven period has loomed so large in the consciousness of Canadians, Jackson's painting during the subsequent thirty-five years has never been examined with sympathetic care. This "later" work has been dismissed wrongly as dull, repetitive, or formulary.

That is not to suggest that there was a radical change in his painting in the years following the break-up of the Group of Seven. Jackson's is essentially a conservative vision, arising from his understanding of the relation of the individual to nature and, particularly, to wilderness. He sought to probe the land's vastness, thrilled by the force of its overwhelming scale, drawn to the texture of its earth. He perceived the essential character of each landscape to be redolent of fundamental truths. This was the central tenet of the Group of Seven, and Jackson lived his life by it.

Nonetheless, Jackson's later work is distinguished by its colour, its texture, and by his subtly shifting attitude to form. In the most general way, the later canvases are "painterly," indicating in their composition little interest in the articulation of discrete forms. In these works there tends to be no single dominating element. Each form in the picture – to the degree that they have any

clearly separate identities at all – sits in equal tension with every other form, in the only spot it could be.

There is a similar change evident in the oil sketches. Never very far in technique from Jackson's artistic roots in France before the turn of the century, the sketches grew increasingly to resemble the romantic naturalism of the nineteenth century in their passionate authenticity; in the deployment of texture, form, and particularly of colour; in evoking the fullest sense of the nature, the animus, of the subject place.

Particular attention should be paid to Jackson's sketches, both because the sketching activity is central to his art, and because they are so movingly beautiful. Arthur Lismer, writing for the catalogue of Jackson's 1953 retrospective, has described their qualities well.

> Jackson is the most consummate sketcher I have ever known. . . . His symbols are inventive and full of meaning and he loses nothing of their freshness in projecting them onto larger areas. There is something cosmic in his interpretation of the movement of earth and sky and weather forms in his paintings, but he never pushes the medium to extravagant expression. Always it seems that he grasps the fundamental unity of spirit and technique.

A number of drawings have been included among the pieces catalogued, although they will not be discussed as a distinct aspect of his work. Jackson saw them as technical tools, and he exhibited them publicly only

near the end of his career. They are, in fact, often exceptional works of art, even though they were first made and subsequently preserved because they offered a simple way of codifying certain information that he could not get in his oil sketches, but which he needed when working on a canvas. They are often all line, to begin with, and Jackson usually made careful colour notes on them, and would place small numbers all over, accurately recording the various tonal values on a scale of one to ten. As did his oil sketches, they habituated Jackson to the remarkably close reading of tone in his views, exercising his eye to discriminate subtle gradations with precision.

Jackson's habits, his routines, the way he organized his life are all of interest, because he arranged everything to serve his painting, primarily his sketching. His sketching method demanded a subject that would command his full concentration, which he gave eagerly because its practice yielded pleasurable fulfilment. He spent his lifetime travelling in search of such subjects. Although he sketched more or less steadily, his strongest work usually resulted from those trips that were determined pursuits. He loved to be where few others had been, where nothing could interrupt to break the concentration, the communion. Then he could get it all down.

In the later years his painting companions were seldom professional artists but were often connected professionally to that particular land they shared with Jackson as a subject for painting. There was an irrigation

expert at Lethbridge (where irrigation is vital), there were geologists, mining engineers, prospectors, ranchers, farmers; all helped him find the good places, places that were intensely characteristic of the region.

These friends constituted a considerable network by the 1940s and 1950s. They were, as well, the core of an informal system of patronage that supported Jackson's work in every way, and to a degree that few Canadian artists have enjoyed. Although a private man, essentially solitary, he was fortunate to find that in pursuing his personal vision he held the centre of a complex network that connected with his country and its people at many points. From that knowledge rose the courage that propelled him so straight and far along his chosen path.

Jackson turned fifty in October 1932, during a period of personal stress and some confusion. If he ever tried to isolate the ebb and flow of frustration and irritation that he felt and sought to identify its source, the strain likely would seem to have started with the Depression following the stock market crash late in 1929, although Jackson's simple life, centred on the Studio Building, where he lived and worked in one large space, did not require much cash. Lawren Harris was his landlord, and he enjoyed the frequent hospitality of many friends, so Jackson never complained of personal hardship during the Depression. Still, he referred often to the misfortunes of others, and the tragic social consequences of the economic disaster were of concern to him.

Against the backdrop of the Depression, two long and complex but basically unconnected dramas unfolded in his life: one public, the other the most intimately private. Jackson's role in each was sharpened by thoughts of mortality, for in late April 1932, his younger sister Isabel took her own life in Montreal. In June, he lost his father, and in November of that year J.E.H. MacDonald died, the first of the originals to go since Thomson.

His public drama began around 1930, by which time it had become generally understood that the Group of Seven had lost its collective drive and focus. The idea began to grow that if the important ideals of the Group were to be sustained as a force in Canadian art, then a new, broadly based national organization must be formed, one that would attract new energy to keep the "Canadian" line growing and developing. The struggle to achieve this transition preoccupied Jackson for months and years.

He did not regret the passing of the old Group. Of all the members, he appeared to be the one who felt most strongly that it should expand. Within a year of its formation Jackson had called for an increase in numbers; and he always encouraged inviting guest exhibitors, a practice that began with the 1926 show. Once it had become clear to all that the Group had exhausted the possibilities of their original organization, it was Jackson who – following the opening of what was to be the last exhibition in December 1931 – announced publicly that "the interest in a freer form of art expression in Canada has become so general that we believe the time has arrived when the Group of Seven should expand. . . ."[1]

Although the time had come, indeed it had arrived more than a year or two before, the desired expansion was still delayed. It has been suggested that discussion dragged over the part the members of the Group of Seven would play in a new organization, and that the final stages of the controversy that ground on through 1932, between members of the Royal Canadian Academy of Arts and the National Gallery of Canada, added to the delay.[2] Senior Academicians were ostensibly protesting the Gallery's incessant promotion of the Group of Seven and its ilk; but actually the Academy was locked in a fundamental struggle with the Gallery over which institution would represent Canadian art and artists both nationally and in the organization of international exhibitions. The Academy finally wanted direct control over the Gallery. In the heat of the fracas, in December 1932, Jackson resigned from the Academy to protest the dominance of its reactionary element.

Jackson's resignation confounded any pretence the Academy had to the nurturing of modern concerns within its ranks. It also established a solid platform for the launching of a new group, and the principal players moved quickly to the count-down. "The Canadian Group of Painters will be sprung on the public next week," Jackson wrote to an artist friend in Montreal at the end of January, "so stand by, comrade. Our first show will be in November at the Gallery here."[3] Twenty days later he wrote again:

On Friday was the first meeting of the CGP. It went off very happily, no pomposity or solemnity, but we put everything through.

Lawren Harris, President; A.Y.J., Vice-President; Prudence Heward, 2nd Vice-President; and Fred Housser, Secretary. Until it is established it will be advisable to hold our official meetings here. Later it may be run from Montreal or Vancouver.

1. Jehanne Biétry Salinger, "Group of Seven Begins Expansion," Toronto *Mail and Empire* (December 7, 1931).

2. Charles Hill, *Canadian Painting in the Thirties* (Ottawa: The National Gallery of Canada, 1975), p. 21.

3. Jackson, Toronto, to Anne Savage, Montreal, January 31, 1933, quoted in Anne McDougall, *Anne Savage: The Story of a Canadian Painter* (Montreal: Harvest House, 1977), p. 104.

Early Snow, Alberta c. 1937
Oil on canvas, 82.5 x 116.8 cm
Kenneth G. Heffel Fine Art Inc., Vancouver

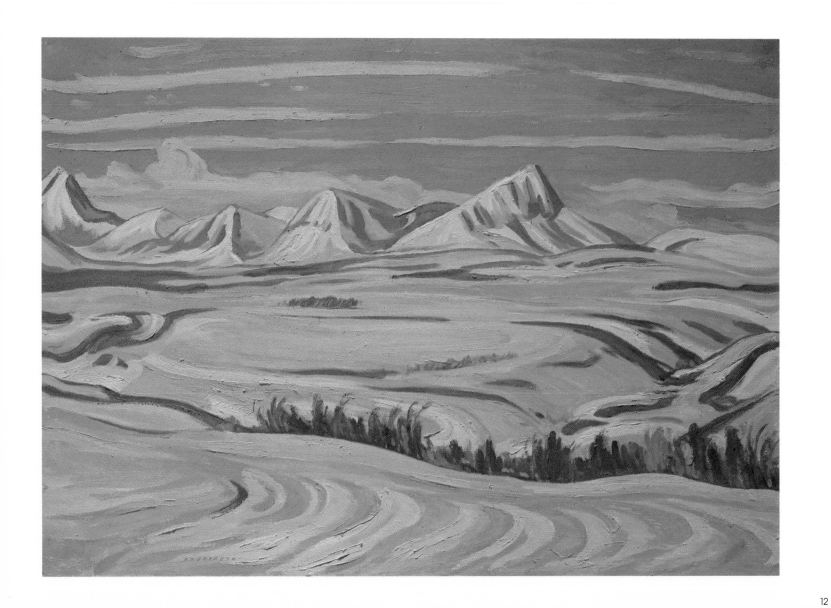

We don't care as long as it moves. It will be announced in tomorrow's papers and our old academic friends will sit up all right. The OSA will feel it first as their show opens in two weeks and most of us are not sending.[4]

Despite the intention eventually to establish a headquarters for the Canadian Group of Painters elsewhere than Toronto, the first elected officers reinforced every possible continuity with the old Group. Harris and Jackson were in command, the latter assisted by a long-time friend and supporter from Montreal, Prudence Heward. The secretary, Fred Housser, was the author of the 1926 volume, *A Canadian Art Movement, The Story of the Group of Seven*, and in 1933 he was still a keen polemicist for those ideals. After space had been reserved in the Art Gallery of Toronto for the first official exhibition of the new group in November, it accepted an invitation to show during the summer at the Heinz Art Salon in Atlantic City, New Jersey. Three years into the Depression, Jackson seemed to be handling his public role effectively and with all of his customary assuredness.

What of that second major role, the one played largely as an interior monologue that moved and shaped the private man? Jackson seldom, if ever, ventured to wear his heart on his sleeve. A life-long bachelor, he inevitably acted as though that condition were the necessary, perhaps even the natural, consequence of his devotion to his art and of the spare, ambulatory life he lived in its service. He may have been right, but there were occasions when he felt that he had to reach out to another human being, even if tentatively, in order to be sure that he had not inadvertently denied himself life's fullness.

The survival of a basket of letters has preserved one of those occasions. Anne Savage, a painter and high-school art teacher

in Montreal, was a close friend of Jackson's throughout most of his adult life. The deep affection he always felt for her had at one time warmed to something near passion (He described himself later as then "rather obstreperous"), but Savage had written back, "just a little severely to make me understand that our acquaintance was nothing more than good friendship. . . . ," Jackson recalled.[5] She was, incidentally, fourteen years his junior.

Jackson wrote to Savage often. Some three hundred letters have survived, including those quoted above in which he relates up-to-the-minute news on the formation of the Canadian Group of Painters. During the period 1931–33 they wrote about once a week.[6] Letters written in May of 1933 show a distinct change of tone, of increasing warmth and concern as Jackson prepared to enter the hospital to have his tonsils removed. Although the operation posed no danger, Jackson knew that, as he was fifty, he would suffer considerable discomfort.

After what appears to have been an ultimately illuminating bout with depression, he recovered normally, and within a month or two was planning his summer. It would include, as had become his custom, a nice long stretch during July and August on Georgian Bay. He wrote to Savage late in June inviting her to come camping on the uninhabited and wind-swept Western Islands with a sketching party organized by his cousins, the Ericksen-Browns. She declined at first, but he finally convinced her to join them, much to his delight.

The visit encouraged Jackson to think again of a more serious relationship with Savage. Although he was confused about the meaning of his feelings, he seemed to realize that he had to overcome his own reticence, that he had a right to express his love. He wrote a series of letters from the La Cloche Hills, where he was camping alone in the fall

of 1933, in which he attempted to do just that. He stated that he wanted her to be his wife, and he tried to anticipate her every objection; but the closest he came to the urgent voice of desire was a confused expression of yearning that he felt for the clean break to a new life that he thought her love might bring him.

> I ought to go west Anne, to the great open prairies and forget about a lot of the unkind things I have thought about people round here, even if there is reason for it, it only hurts one's self and that is why when I wanted so much to tell you that I loved you out on the Western Islands the words would not come. I should come dashing in from the western plains and sweep you off your feet because you're such a darling. . . .[7]

Before Jackson returned to Toronto at the end of October for the preparation of the first Canadian Group of Painters exhibition at the Art Gallery, they must have decided that marriage was not the answer and that things should go on as before. Jackson and Savage from that time felt a special closeness and security in the other's caring; but it was clear they would remain essentially separate, never to be swept up in love's urgent conspiracies.

Was Jackson as pleased with his role in this private drama as he was with his performance on the public stage? Probably. Pragmatic solutions had been achieved in these two areas of his life, satisfying enough to his

4. Jackson, Toronto, to Anne Savage, Montreal, February 20, 1933, quoted in McDougall, *Anne Savage*, p. 105.

5. Jackson, Cobalt, Ont., to Anne Savage, Montreal, October 3, 1932, quoted in McDougall, *Anne Savage*, p. 95.

6. McDougall, *Anne Savage*, p. 84.

7. Jackson [in the La Cloche Hills], to Anne Savage, Montreal [September 1933], quoted in McDougall, *Anne Savage*, pp. 117-19.

self-esteem. Others did not seem to him to be doing so well: out in Vancouver Fred Varley had left his wife. Jackson's close friend and sketching companion, Dr. Frederick Banting, had undergone a difficult divorce in 1932. And his closest friend among the old Group, Lawren Harris, with whom he had visited the High Arctic on an epic voyage in 1930 and who was his co-officer in the Canadian Group of Painters, was struggling with great changes in his life.

Harris had become increasingly involved with spiritual concerns in his reading and through his association with members of the Theosophical Society of Canada, concerns that he found difficult to express in visual terms and that some of his friends and family undervalued. In a letter to LeMoine FitzGerald in Winnipeg following the 1931 Group of Seven exhibition, Bertram Brooker explained that "Lawren has done no painting for six months and very little for a year. All of his things – mostly of the Arctic, I had seen at his studio often. The general impression, freely voiced, seems to be that he is repeating himself and has got to the end – of a phase, at least."[8]

Harris produced virtually no new work in the following years. He exhibited canvases from the mid-1920s in Atlantic City, and he selected examples from throughout the 1920s, the "high period" of the Group of Seven, for November 1933 at the Art Gallery of Toronto. The issue came to a crisis finally in the summer of 1934, when he left his wife and declared his love for a fellow theosophist, Bess Housser, the wife of long-time friend Fred Housser, Secretary of the Canadian Group of Painters. Because of his family's social standing and the drama of the affair, Harris found himself the centre of a scandal. He and Bess Housser pressed urgently for divorces. Agreements were reached, and they went to the United States to marry. They were

settled in Hanover, New Hampshire, by the fall. The following June, Fred Housser married the Toronto painter Yvonne McKague. Jackson felt confused and somehow betrayed by it all. There was no Canadian Group of Painters exhibition in 1934, nor the following year.

Jackson withdrew, and even considered leaving Toronto, perhaps moving back to Montreal.[9] He was at times outspoken on Harris's actions, and some thought that he acted badly. Varley saw an easy explanation for his behaviour. "I find poor A.Y. feeling sorry for himself because Lawren entering more deeply, or numbing himself with theosophy, attracted a little crowd of youthful admirers who were so goggle-eyed that they failed to see our husky friend A.Y."[10] Jackson was out of the country at the time of Varley's remarks. He had left late in May for Europe with his niece Naomi, accompanied on board ship by Arthur Lismer, his wife, and their daughter Marjorie, on their way to spend a year in South Africa, where Lismer was to advise the various local educational authorities on the role of art in their systems.

It was Jackson's first trip back since the war, and the ostensible reason for the journey was to attend a reunion of army veterans in England. He had also seized the occasion to travel with his niece, a graduate student on her way to Germany where she would be researching the life and work of Ernst Barlach. Jackson would take the opportunity to re-visit Paris and Belgium, and to stop briefly in Germany for the first time, but he had taken the trip mainly in order to get away.

There finally had been a second CGP exhibition in January 1936, opening at the Art Gallery of Toronto again, but not going on to the Art Association of Montreal as the 1933 show had. And Jackson had entered works in the Ontario Society of Artists exhibition in March, the first time since he had withheld

submitting three years earlier. So even as he had prepared to flee a situation that had become too unsettling, he was working toward its stabilization. The following year he again contributed to the OSA as well as to the third CGP exhibition, held in the then usual month of November. This time it again went on to Montreal in January.

The pattern of sketching trips began to return to normal as well. Two years earlier, in 1935, probably his most difficult time in Toronto after the fall of 1934, he worked chiefly around the old haunts in Quebec, not only in the late winter and early spring as was customary, but during the summer months too. Then, in 1937, he was in his usual fashion back on the North Shore of the St. Lawrence with Dr. Banting for the early campaign, and on Georgian Bay for the summer; but instead of heading to the La Cloche Hills region north of Georgian Bay, his usual autumn sketching ground, he turned to the great western plains and the foothills of Alberta.

Jackson appears to have given no special significance to this alteration in his routine, even though it marked a distinct change, as he returned regularly except for a brief interruption during the war. He opens the chapter "Painting in the West" in *A Painter's Country* as naturally as turning a page:

In 1937, I went to Alberta to paint. I had been there previously to visit my brother Ernest, who has lived in Lethbridge since 1906, but although I found the country intriguing, I had never made any serious effort to paint it.[11]

In fact, we know from his letter to Anne Savage written in the La Cloche Hills in the fall of 1933 that the west of "the great open prairies" tugged strongly with its promise of vast space and unfettered movement, of an

escape to freedom, of renewal. Such romantic feelings could not have been allowed to dominate for long, but self-consciousness would hardly have dampened his real eagerness to get out on the prairies: "Let's go Anne and paint them red."[12]

Savage was not with him when he set out on his first southern Alberta campaign; she never was to sketch with him in the West. Jackson travelled by train to his elder brother Ernest's home in Lethbridge, arriving during the third week of September 1937, intent upon a long stay. Through his brother he met or renewed acquaintance with his brother's friends, and with members of the Lethbridge Sketch Club, particularly Frederick Cross, a hydraulics engineer, irrigation expert, and enthusiastic water colourist. Cross was soon driving Jackson all around southwestern Alberta, although they seem to have sketched chiefly west of Lethbridge, on the route to the Crowsnest Pass.

Jackson was at the Bar X Ranch near Pincher Creek in the foothills by September 20, where he sketched an early snow fall. They visited Lundbreck, an old coal mining town, and Cowley, both also along the line. As he relates in A Painter's Country, he chose Cowley as the place for some concentrated work, and took the train out for a stay early in November. By the middle of the month he was back in Lethbridge, and then on home to Toronto with his sketches and drawings. His friend Frederick Cross recorded his stay in an article in the Lethbridge Herald of November 17. Jackson had met a number of sensitive, cultivated people in southern Alberta, who admired his work and enjoyed his company, and who would become dear friends over repeated visits.

The trip did, then, fulfil some of his expectations of a new start, or at least broadened his horizon. Should we then be looking for some consequent change in his painting?

Jackson had been firm in the basic tenets of his art for some time. Landscape attracted him to the exclusion of virtually everything else, and it was the underlying rhythm of the land, as much evident in the intricate relationship of its parts as in its broad forms, that moved him. He sought to capture the particular sense of vital life that each place gives up in the light of its own special atmosphere.

Jackson's great understanding of the formal capabilities of his art was turned entirely to capturing the essential nature, the sense of the living continuity of his view. Unlike Lawren Harris, for example, he did not objectively seek to develop the formal elements of his art in order to approach the spirit of their force. He remained a curious sort of husbandman, tied to the wild land in communion, like Tom Thomson. When, as is often the case in his work, human habitation is part of the scene, it is in complete harmony with the rich, rhythmic, ever-so-slowly rolling stream of life that is the constant subject of these pictures.

The scale of the Alberta sketches, such as Porcupine Hills, Alberta (No. 15), painted on his return to Lethbridge the following year, is essentially the same as those done in Quebec. This is most apparent in the scenes of villages, where the point-of-view is distant enough from the structures to establish their relationship to the land forms, yet close enough to show clearly their configuration. The colour of the Alberta sketches differs from those of Quebec, however, and the rhythm of the land is different in each region. There is a stronger sense of direction in the Alberta paintings – lateral. Nonetheless, technically and conceptually, they are the same work as Jackson did at St. Tite des Caps the previous spring, and essentially the same work he had been producing since 1914, or even since France. None of this alters the fact that these Alberta sketches are fresh, emphatic images, full of the palpable presence of southern Alberta.

Back in Toronto, Jackson produced canvases for the shows, which given the late date of his return, meant first the 1938 exhibition of the Ontario Society of Artists (He had pretty well stopped showing in the Art Association of Montreal Spring Show), and the Canadian National Exhibition. There was no Canadian Group of Painters show in 1938. Apparently by way of a statement, he showed only two works with the OSA, one called Quebec, the other Alberta, now known as Alberta Foothills (No. 13). He showed a large crowd-pleaser at the CNE at the end of the summer, a stylized study of a big metal smelter, Smoke Fantasy, probably based on the plant at Sudbury. It has since been lost from public view. The previous year he had shown a similarly dramatic and stylized (and subsequently elusive) picture, Snow in October, likely based on a site in the La Cloche Hills. Both accomplished the immediate goal of being illustrated in their respective catalogues. He exhibited no Alberta scenes the following year, and none again, in fact, until 1945.

That first public evidence of his western trip, Alberta Foothills, could hardly have presented a striking contrast to the Quebec canvas it was exhibited with in March 1938, except, perhaps, in its colour. Jackson had

8. Bertram Brooker, Toronto, to LeMoine FitzGerald, Winnipeg, January 10, 1932, FitzGerald Study Centre, School of Art, The University of Manitoba, Winnipeg.

9. McDougall, Anne Savage, pp. 143-44.

10. Fred Varley, Ottawa, to H. Mortimer-Lamb, Vancouver, June 6, 1936, Archives of the McMichael Canadian Collection, Kleinburg, Ontario.

11. A.Y. Jackson, A Painter's Country (Toronto: Clarke, Irwin & Company Limited, revised "Centennial Edition," 1967), p. 123.

12. Jackson, Toronto, to Anne Savage, Montreal, November 21, 1933, quoted in McDougall, Anne Savage, p. 121.

COLOUR PLATE NO. 2 (No. 23)

South from Great Bear Lake c. 1939
Oil on canvas, 81.3 x 101.6 cm
Art Gallery of Ontario (L69.21)

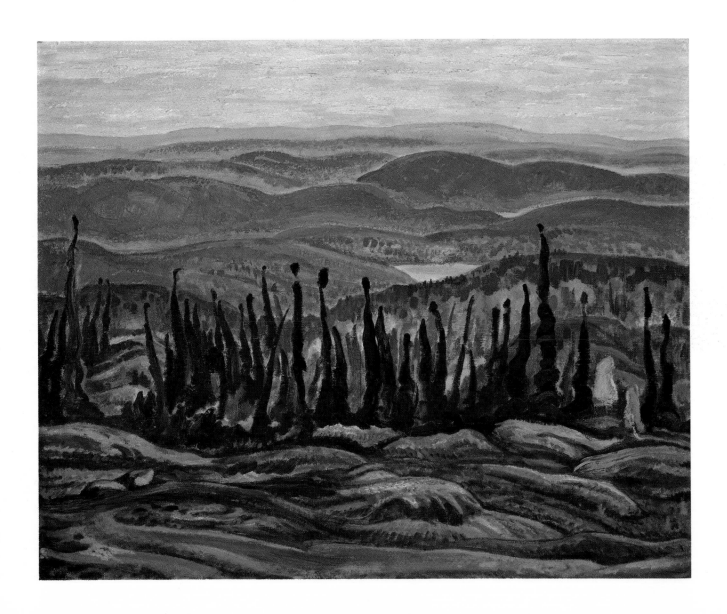

managed to find in the foothills a terrain remarkably similar to the humpy, rounded forms of the worn-down Laurentians of his sketching grounds on the North Shore. He painted at least two other canvases based on Alberta sketches of 1937, but exhibited them only years later, after both had been sold. One, *Blood Indian Reserve, Alberta* (No. 12), follows the composition of earlier works, for instance *Algoma, November* of 1935 (No. 4), with the added device of a country road, penetrating the space to link the foreground with the distant back-drop. It is effective but, like *Alberta Foothills*, familiar in the context of his contemporary work.

The other canvas, *Early Snow, Alberta* (No. 14, Pl. No. 1), was sold privately soon after it was painted, and he exhibited it only much later, in 1950. It does stand apart from the Quebec canvases, even though it, too, follows a familiar compositional format with clear foreground, middle, and back. If we compare it with a Quebec picture, such as *Valley of the Gouffre River* of 1933 (No. 2), we can see that there is a real expansiveness, a scale to this picture that the Quebec and even the other early Alberta canvases lack. A broad, majestic, and sweeping rhythm holds sway, so unlike the compacted roller-coaster ride of the Laurentian hills. The still-strong, though slightly raking, light of late September casts the snow into a delicate meringue of blue. It is in the sweeping orchestration of this blue – that ethereal colour in subtle interplay with the rich, overblown reds, ochres, and browns of the racing lines of windbreaks and ridges of exposed earth, and touched here and there and in so many unexpected places with pastel, complementary hues – that the space is set, and from which derives that wonderful sense of the earth pressing out, a living organism. As an experience, it is unlike our response to the flush of life's renewed urgings in the late-winter scenes of Quebec. If

not so much a distinct turning, for Jackson it represented at least a new dimension.

Yes, a new dimension, rather than a turning, because Jackson was enlarging his horizons on a number of fronts. In 1938, a new pattern of sketching trips emerged, a pattern that was broken immediately by the war, but that would re-emerge later and govern his routine for many years. Even though that year was played out against the gathering clouds of war, it seems to have been relatively calm and productive, particularly in light of the disruptive storm to follow.

Jackson began the sketching season about the middle of March in the Georgian Bay area. He had to travel to Washington in April, but in May was off to Grace Lake in the La Cloche Hills region. He was back on Georgian Bay during the last two weeks of July. Then, at the end of August, he headed west again, this time to Edmonton, where Gilbert LaBine had arranged for Jackson to be flown up to his Eldorado Mine on Great Bear Lake in the Northwest Territories. He arrived August 26 and stayed until October, six weeks in all, hiking all over the country around the radium mine at Labine Point and, upon at least two occasions, travelling farther by boat. The vast scale thrilled him. "The skies are far away," he wrote to his niece, "and everything that takes place does it over a thousand square miles. . . ."[13] Returning to Edmonton in October, he went on to Lethbridge for a couple of weeks of sketching in southern Alberta before returning home.

Of the canvases painted from drawings and sketches done on Great Bear Lake that year, the most magnificent, the one that gives the fullest sense of that unusual country with its thousands of lakes among thousands more hills, is *South from Great Bear Lake* (No. 23, Pl. No. 2). That far north in late September, when looking south we are looking directly into the sun's diffused rays. They

are strong enough to back-light dramatically a line of the region's rudimentary trees that stand silhouetted against the vast homeland of their species. Clumps of these snake-like bushes are scattered across the organic lumps that make up the landscape, and over it all, on and among the multitude of rounded rocks that is its surface, runs a rich, multi-coloured carpet of robust plant life. Although the dense vegetation in no way obscures our view, its pervasiveness instils a sharp, unsettling sense of the sublime. Is there a place for man in such a land?

Jackson thought so, and, indeed, his attention would be drawn increasingly to that extensive part of the country that neither contained the soil nor enjoyed the climate to sustain a settled life, but that nonetheless drew hardy, adventurous men with its promise of hidden wealth. Another important canvas of the late thirties, *Algoma Lake* (No. 27), suggests in its subtle and multifarious mineral hues of iron rust through brass to flashing silver, platinum, and hints of even more rare and precious ores, the deep and complex attractiveness of this land of swelling, rippling rock. It is a brazen image, half promise and half taunt, yet somehow delicate in that balance. The exploitation of this land will not involve the attentive ministrations of the farmer, but rather the cracking and smashing of that smooth rock, the construction of hellish smelters and of roads and tracks driven through where the hard land resists the least. In the subtle harmonies of his colours – so truly delicate if we allow our eyes to linger – Jackson seems to have sensed the essential vulnerability within this strength of balanced forces.

If we look back over some major works of

13. Jackson, Port Radium, N.W.T., to Naomi Jackson, September 19, 1938, quoted in Naomi Jackson Groves, *A.Y.'s Canada* (Toronto: Clarke, Irwin & Company Limited, 1968), p. 208.

Wild Woods c. 1945
Oil on canvas, 53.7 x 66.4 cm
Vancouver Art Gallery (49.16)

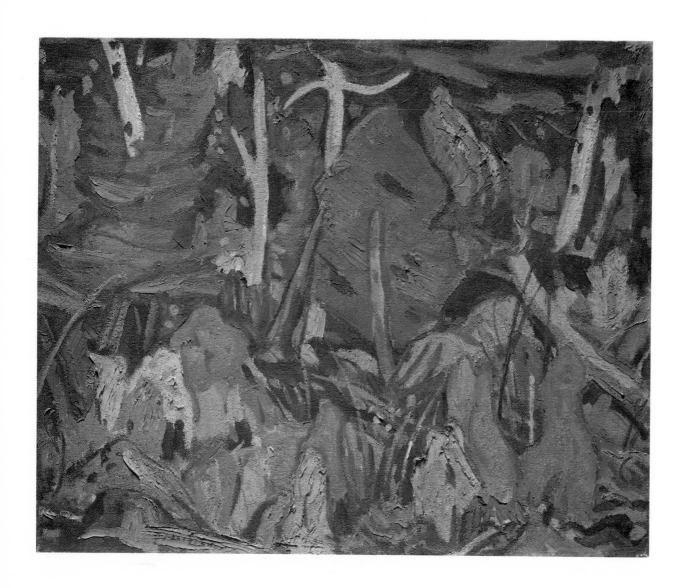

the thirties – *Valley of the Gouffre River*, *Early Snow Alberta*, *South from Great Bear Lake*, and *Algoma Lake* –canvases from the four regions of the country that attracted him the most that decade, we will not see any significant change in handling (Each displays the strong but loose brushwork of his maturity), or even, for that matter, in composition. But, although his long-time concern to draw out the underlying rhythmic forms of the landscape is clear in each case, a comparison of these four paintings shows that he has isolated the unique rhythm of each place. Even more obviously, there is a distinctive dominant hue to each work and, more subtly, a particular observed density of atmosphere. Each place to him is significant in its way, compelling in the implications of its nature. To identify and to record in a manner that is fully redolent of that nature was his goal and his accomplishment. As war broke, he knew that one thing for certain.

The early war years were grim. Jackson did not travel west, but spent time each year throughout the war with his brother Henry's family in the region of their summer home at St. Aubert in L'Islet County on the South Shore of the St. Lawrence. He sought familiar comforts in other ways as well; between 1939 and 1941 he was once again writing to Anne Savage in Montreal about once a week.[14] Initially his work suffered, as he reported to his friend Harry McCurry, the Director of the National Gallery of Canada. "I am trying to do some [paintings] but it is hard to get enough excitement in them. I don't know of any artists who are painting."[15] He was still visiting the La Cloche Hills and Georgian Bay regularly, however, and he spent more time sketching in Quebec. Late in 1940 he became involved in a film the National Film Board was making on his work; and the next year, he travelled to Algonquin Park to help with another NFB production, this one on the life and work of

Tom Thomson. He began writing more. Early in the war he produced a small booklet on painting for the YMCA, wrote a couple of articles on current affairs from an artist's point of view, and a number of letters to the editor on various issues. Between October 1942 and the spring of 1946, he turned out a more-or-less regular column for the *Toronto News*.

Wartime restrictions on the international transfer of Canadian funds brought Lawren Harris back to Canada in 1940. He had moved from Hanover, New Hampshire, to Santa Fe, New Mexico, and upon his return, decided to settle in Vancouver. He stopped in Toronto to make these new arrangements, and Jackson saw him frequently. Writing to McCurry, Jackson revealed a lingering ambivalence toward his old friend. "Lawren left here Sunday for Vancouver, where he is going to settle for the present. He should liven up the boys round there, or he may merely get them interested in reincarnation."[16] Harris was still Jackson's landlord at the Studio Building.

Arthur Lismer, who had been away from Toronto, travelling abroad in the interests of children's art through most of the later 1930s, settled in Montreal in 1940, where he took over the educational program at the Art Association of Montreal (now the Montreal Museum of Fine Arts). As he approached sixty, Jackson was generally acknowledged to be the leading artist in Toronto. His contribution to Canadian art was formally acknowledged in October 1941, when he received an LL.D. from Queen's University at Kingston. To celebrate this event, and to premier the new NFB film on his work, a grand evening was held at the Art Gallery of Toronto, January 30, 1942. Lismer was the key speaker, and he was superb. Praising Jackson, he described how in the element of colour, "A.Y. is supreme":

In my jealous moments I could call him a prevaricator –because I can't see it –and

fortunately few others can achieve it –as in this respect he is inimitable. But for pure enjoyment this painter of Canada in technicolour is a master. I know there are stranger colours and deeper richness in many of Thomson's canvases, but for form *plus* colour, in rhapsody and in sobriety, in season and in tune, and place, Jackson's sketches, particularly, express a reality and a conviction that he has grasped a whole stretch of lake-land or winter landscape with its symbol of convincing wholeness, and has made of the colour itself a form of adoration and revelation of Canadian character. The landscape painter *has* to compose –to boil down, as it were, his own optical impression to diminutive proportions. A.Y. retains the quality and identity of the whole. His sketch becomes the unit, as it were, from which nature took its theme.[17]

The Jackson of the early 1940s was described by another eloquent analyst of the arts, Wyndham Lewis, the British artist and writer, who was trapped by circumstance in Toronto between November 1940 and June 1943. (He then moved to Windsor and finally spent three months in Ottawa before returning to England at the end of the war in 1945.) Lewis moved into the Studio Building in March 1941.[18] He and Jackson spent some time together over the following months.

14. McDougall, *Anne Savage*, p. 84.

15. Jackson, Toronto, to H.O. McCurry, Ottawa, January 14 [1940], Central Registry of the National Gallery of Canada, Ottawa.

16. Jackson, Toronto, to H.O. McCurry, Otttawa, December 6 [1940], Central Registry of the National Gallery of Canada, Ottawa.

17. Quoted in O.J. Firestone, *The Other A.Y. Jackson: A Memoir* (Toronto: McClelland and Stewart, 1979), pp. 182-83.

18. Jackson, Toronto, to H.O. McCurry, Ottawa, March 27 [1941], Central Registry of the National Gallery of Canada, Ottawa.

Jackson understood Lewis's plight, and he records in his autobiography that "he was an exile and they were not very happy years. In Toronto only a few people realized what an important figure he was in both art and literary circles."[19] Writing to his friend McCurry at the time, Jackson revealed a somewhat more human – though narrower – view of their relationship:

Getting a little leary of Mr. Lewis (Wyndham). I rather befriended him because everyone was so down on him. For some time I could see where things were heading, extreme flattery about my work – put on too thick, and big talk of forthcoming royalties, commissions in the U.S. etc., and then *temporary* embarrassment and loans, and loans and what I can live on for a month is just chicken feed for him.[20]

Back in England, Lewis took the occasion of a review of Donald Buchanan's *Canadian Painters, From Paul Kane to the Group of Seven* (London: The Phaidon Press, 1945) to evaluate Jackson's place in the Group of Seven, indeed, in Canadian art, for the Group seemed to Lewis to have achieved the fullest expression of a distinctive Canadian visual culture. "The members of this group are dispersed, have 'gone west', have disappeared or died," explained Lewis.

Only Jackson is left. He had much to do with starting it all: now he stands there alone in Toronto before his easel, in the Studio-building in the Ravine, painting doggedly, the 'grand old man' of Canadian painting. . . .
 Jackson interests me the most. He is himself like a bit of nature – and I have explained how it is the nature we see in the Group of Seven, however imperfectly, that gives them their real significance – and the rock is always more important than the man. . . .

The village is not where Jackson is most at home. He has painted some excellent villages: but where there are few signs of man is where he really likes to be. Where there is just Jackson and Nature. 'Nature' for Jackson does not mean what it did for Turner, a colossal and sumptuous pipe dream akin to the Kubla Khan of Coleridge, nor what it was to Van Gogh, a barbaric tapestry, at the heart of which was man and his suffering – his human rhythms branching out, the tormented nervous system of nature responding to man's emotions. In Jackson's case it is nature-the-enemy as known to the explorer.
 Yes, it is an affair of Jackson-against-nature and vice-versa. Jackson being what is called a 'fighter' likes this situation. His painting seasons are as it were *campaigning seasons*, rather than the breathless rendezvous of a 'nature-lover' with the object of his cult. It is impossible to associate the notion of pleasure with these grim excursions, or at least nothing sensuous. . . .
 There is gaiety sometimes in Jackson, but it is rationed. His vision is as austere as his subject-matter, which is precisely the hard puritanic land in which he always has lived: with no frills, with all its dismal solitary grandeur and bleak beauty, its bad side deliberately selected rather than its chilly relentings. This is a matter of temperament: Jackson is no man to go gathering nuts in May. He has no wish to be seduced every Spring when the sap rises – neither he nor nature are often shown in these compromising moods. There is something of Ahab in him; the long white contours of the Laurentian Mountains in mid-winter are his elusive leviathan.[21]

A somewhat glib interpretation of Jackson's personality, it is not, as we have seen, an entirely accurate description of his relationship to his chosen landscape. Neither Jackson in his letter to McCurry, nor Lewis in this article understood more than a small, obvious part of the other person.
 Both Lismer's remarks and Lewis's article do underscore, nonetheless, the pre-eminence Jackson enjoyed on the Canadian art scene in the early 1940s. It was likely his own sense of that position that led him to begin showing again with the Royal Canadian Academy in 1940, although this brief return lasted only three years. And he even allowed his work to be included in a survey of current Canadian painting mounted by the Contemporary Arts Society in Montreal late that year, although he was an avowed opponent of that modernist movement, and his utter lack of respect for their efforts was widely known. "Have not heard much about the Contemporary Art show in Montreal," he wrote to McCurry in December. "Their strong suit is having two newspaper men in their society Surrey and Bob Ayre, and Lyman as well. The publicity is better than their shows I imagine."[22] Even though he held a number of one-man shows in commercial galleries in Montreal during the 1940s, his allegiance remained with the Toronto community, centred upon the Canadian Group of Painters – which managed to stage another exhibition in 1942 – and the Art Gallery of Toronto. He had entered fully into the affairs of the Gallery as a member of the newly established Canadian Purchase Committee, based on two funds set up to honour old friends of his, Albert H. Robson and J.S. McLean.
 Jackson exhibited small canvases of Quebec during these years, and larger paintings based on his annual trips to the La Cloche Hills. At the CNE in 1941 he showed a

big canvas, *Autumn, Algoma*. This is likely the canvas now known as *North Country Algoma* (No. 28). It is an aggressively public piece, constructed with broad yet complex rhythms, reinforced not with dark outlines, as had been his custom, but through a full range of hues, a palette unprecedented in his work. Strong and affecting, it is a bravura display of his mastery of colour. As much as we can admire his brilliant technique, however, we miss the acute sense of place. It is more Jackson than Algoma, a grand expression of *his* place in the world of art.

Jackson exhibited less during the later war years. After 1942 he again stopped submitting work to the RCA. The CNE shows were cancelled after 1941 as a wartime measure, and the CGP didn't arrange an exhibition for 1943. Jackson continued to ignore the Art Association of Montreal spring show. He did exhibit regularly with the OSA, and held a small exhibition of Quebec work at the Art Association of Montreal in January 1943, shown with watercolours by his brother Henry (who made exquisite studies of fungi), and landscape paintings by his niece, Henry's daughter, Naomi. Later in the year he published a slim volume in appreciation of the painting of his sketching companion, Sir Frederick Banting, for the Ryerson Press's Canadian Art Series. Banting had died in a plane crash in Newfoundland in February 1941 on a military-related mission to Britain. The public Jackson, however, as suggested by his *Toronto News* column, was determined to contribute to the war effort beyond the narrow confines of the Canadian artistic world.

Harry McCurry's proximity to government meant that he could help, and it was under the auspices of the National Gallery of Canada that Jackson, with the Toronto painter A.J. Casson (who, in 1926, had become the youngest member of the Group of Seven), in

1943 became involved in the production of some 17,400 silk-screen reproductions of Canadian paintings for distribution among the Armed Forces. Jackson was also one of a number of artists who pushed the National Gallery to institute a war records program similar to that established by Lord Beaverbrook during the First World War. Although artists who had enlisted for active service in some cases had already been assigned to recording duties, the official war records program began only in January 1943. Many of Jackson's younger friends were involved, including George Pepper of Toronto.

Pepper had planned to teach at the Banff School of Fine Arts the summer of 1943, and when he decided instead to enlist, he asked Jackson to take his place at Banff. Although Jackson had done very little teaching before, he jumped at the chance to return to Alberta. Following his stint at the school, in September he visited a number of his students who lived in the region, at Canmore and Rocky Mountain House, and spent some time in the Lethbridge area again, with a short trip at the end of the month to Waterton Park in the extreme southwest corner of the province. He didn't work a great deal. He was trying to find a place in the war records program himself.

Jackson was too old to be commissioned as an artist-officer on the war front, but McCurry thought that he could arrange for him and H.G. Glyde, a Calgary painter, to memorialize the completion of the Alaska Highway. Though built entirely by the American Army Corps of Engineers, it did pass through northern British Columbia and the Yukon, and represented a vital link in the Allied defence of the west coast. (It has since become an essential part of Canada's transportation system.) It also got Jackson into the Northwest again. The National Gallery supplied the artists with letters of introduction and, thus armed, Jackson headed for

Edmonton. He recalls the preparations in his autobiography:

It took considerable time to arrange for permits and for authority to sketch along the Alaska Military Highway. There was an elaborate exchange of telegrams and air mail letters between myself in Southern Alberta and the National Gallery at Ottawa before it was accomplished; so it was not until the 14th of October that Glyde and I landed at Whitehorse in a big transport plane.[23]

From Whitehorse, they were first driven west to Kluane Lake, near the Alaska border, and then, following their return to Whitehorse, were motored the 850 miles southeast to Dawson Creek, where the highway linked up with the old road to Edmonton. That run, with stops for sketching, took nearly a week.[24]

The US Army, which gave them every consideration, was their host for the whole trip, except for a stop at Fort Nelson, where they spent the night with the RCAF. They got as far as the Peace River Bridge, just north of Dawson Creek, then returned the short distance to Fort St. John, where they joined a lively party in the RCAF officers' mess before leaving by plane at one in the morning for Edmonton. Jackson stopped in Lethbridge

19. Jackson, *A Painter's Country*, p. 131.

20. Jackson, Toronto, to H.O. McCurry, Ottawa, September 30, 1941, Central Registry of the National Gallery of Canada, Ottawa.

21. Wyndham Lewis, "Canadian Nature and its Painters," *The Listener* (August 29, 1946), in *Wyndham Lewis on Art, Collected Writings 1913–1956* (New York: Funk & Wagnalls, 1969), pp. 427-29.

22. Jackson, Toronto, to H.O. McCurry, Ottawa, 6 December [1940], Central Registry of the National Gallery of Canada, Ottawa.

23. Jackson, *A Painter's Country*, p. 144.

24. *Ibid.*, p. 146.

April Day, Ste. Marthe, Gaspé 1953
Oil on canvas, 51.5 x 64.1 cm
Private collection

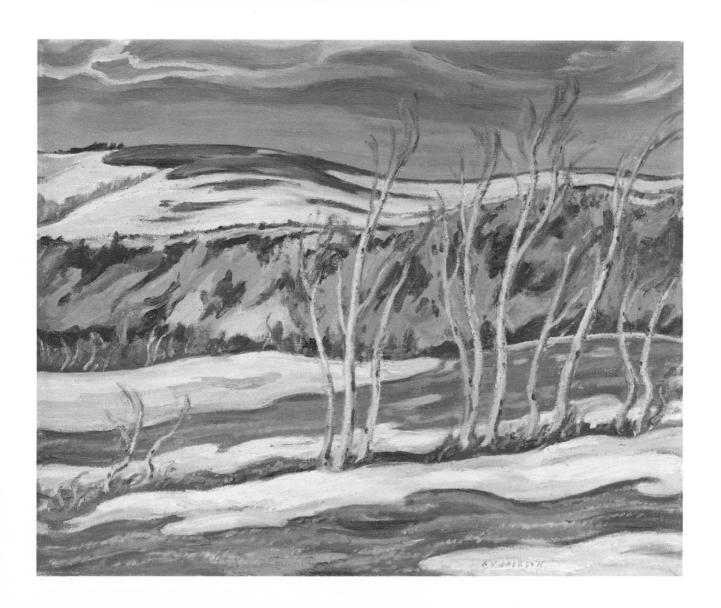

COLOUR PLATE NO. 5 (No. 52)

Country Road, Alberta c. 1954
Oil on panel, 26.7 x 33.4 cm
Art Gallery of Ontario (81/539)

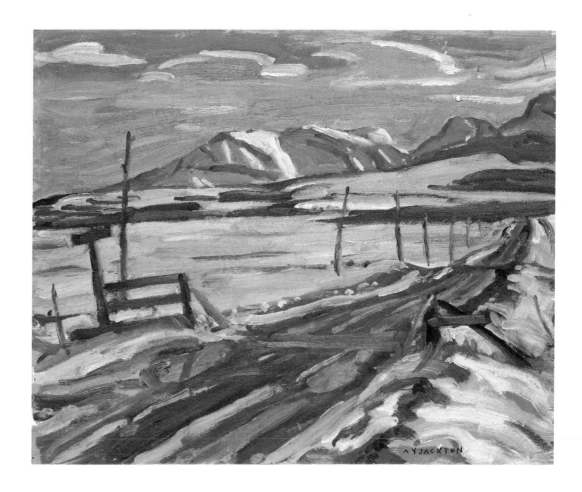

again before returning to Toronto. The *Leth-bridge Herald* recorded his immediate reactions.[25] He had turned sixty-one just before undertaking the journey.

Jackson's sketches – the best of which are in the collection of the National Gallery of Canada – record the journey as well as the landscape. It may have been the rush of it all, or perhaps the foreign hosts, but the best images are of small vehicles beetling along the rough track, pressing on from post to post. Wilderness bush and surrounding mountains push in on the solitary travellers. Back in his Toronto studio he began to synthesize his experiences, and produced at least three canvases that express the nature of the country.

None of these approach the scale of *North Country Algoma*. One, now in the Art Gallery of Greater Victoria, entitled *Northern Lights, Alaska Highway*, was used as a poster in aid of the war effort. (It had an airplane in the sky then, since painted out.) The others are not as generalized, and represent a more direct experience of the landscape. *Mountains on the Alaska Highway* (No. 32), which depicts the mountains on the Haines Road near Kluane Lake in the Yukon, approaching the Alaska border, focusses entirely on the sense of the place. There is nothing in it that is topo-graphically outstanding except perhaps the dream-like range of mountains that floats beyond the horizon, probably on foreign soil, Jackson's glimpse of Alaska. The picture is rather about the rudimentary forms, the rude texture, and the spare colours of the late fall in sub-Arctic Canada. This is the first of his canvases – similar ones would always be of this intermediate size – to adhere so closely to the local colour and the unrelenting coarse-ness of the tundra. At first glimpse it is ugly. But we must look more closely to discover the satisfying blend of purples and browns that enlivens the dense screens of trees. Pretti-

ness never enters our minds as we luxuriate in the rich though close colour range of autumn decay, the prickly, rigid forms and repellent textures of the primitive plant life. This is fundamental, with no concession to the taste of his day. Jackson knew that the closer he attended to the mood of the land, the stronger his song would ring.

In 1944, feeling that he really was back in action, Jackson sought to repeat the long and successful western season of the year before. It began again in the spring with a stay of about three weeks at his brother Harry's place at St. Aubert. Then he was off to Banff for the summer, followed, as the previous year, by visits to the homes of some of his students and, in September, with his brother Ernest in Lethbridge. Plans to return to the Alaska Highway fell through, much to his disappoint-ment, and he and Glyde ended up instead sketching around Rosebud, east of Calgary on the road to Drumheller. It was, none-the-less, a good season, as he reported to his niece: "Have had a busy time sketching in Rosebud, Kamloops, Canmore, Cowley and Pincher Creek. . . . Getting to know the west."[26]

Again in 1945, the pattern was followed almost exactly, although he arrived at his brother's in St. Aubert earlier and departed sooner, on VE Day, May 8. After Banff, he spent some time in the Cariboo region of Brit-ish Columbia, as well as around Lethbridge. In 1946, for the first time in five years, he returned to the North Shore for spring sketch-ing in Quebec – a sign of returning to normalcy following the war. But the newer routine persisted during the rest of the year: summer at Banff followed by sketching in the Cariboo and in southern Alberta until late October. He was pleased with his work and felt he was at the height of his powers, although he was disturbed a bit that his approach attracted few younger adherents.

"There is some grand country in the west," he wrote to his niece at the end of the year. "The problem is that there is no place to stay where the best sketching is. You need a car and trailer. That kind of art and adventure is to me what Canadians should be interested in, but hardly anyone is doing it. They are going abstract and pottering with new tech-niques. . . ."[27]

Jackson himself had been pottering. In March 1945, he showed a small canvas called *Wild Woods* (No. 33, Pl. No. 3) with the OSA, and then, in April 1946, exhibited it again, rather surprisingly, at the Art Association of Montreal spring show. It was the first time in seven years that he had appeared there, and it would be the last. Hardly an attractive picture, *Wild Woods* does display a great deal of skilful brush work, and comes close to being a virtuoso performance in colour. Intense, saturated hues are manipulated to no evident pictorial purpose, but rather to satisfy formal relationships, all of which hinge on a dominant magenta shape in the centre. It may have been Jackson's idea of modern-ism, of approaching abstraction, displayed in Montreal in an attempt to bring authority to his vociferous criticism of those painters (most of whom, of course, were members of the Montreal-based Contemporary Arts Soci-ety) who promoted such tendencies in Cana-dian art. It certainly did not mark a turn in his work.

The landscape of Alberta was his real inter-est during the second half of the 1940s and he returned to Banff and to fall sketching in the region again in 1947. He did not teach the following year and, in fact, failed to make it west at all. He was back to the Cariboo and southern Alberta again the spring and early summer of 1949, however, and taught again – for the last time – at Banff that summer. Alberta dominates in the work of the later 1940s. Many sketches survive that are

charged with the immediacy of the prairies and the foothills; they are alive with the special atmosphere and colour of his favourite spots, such as Canmore or Pincher Creek (see Nos. 34 and 35). The small Alberta canvases of this time are also remarkable for their intensity of mood, their particularity. There is one large canvas, however, that presents most forcefully and comprehensively of all of his work an understanding of the fundamental nature of southern Alberta.

Alberta Rhythm (No. 39 and cover) is one of Jackson's finest paintings, equal in its own way to any in his long career. Its majestic, solid drawing (No. 38) is a commanding, detailed study of the forms and textures of the fluid hills, the sharply cut coulees and shallower ravines picked out dramatically in the strong, raking sunlight. That it has so completely caught the scene makes his skilful use of colour in the painting the more wonderful. The bolder forms, the major rhythms, are brought into a complex yet subtle harmony with all of the lesser elements through the exact placement of one precisely valued hue next to another, so that the landscape rolls and turns in continuous motion, yet is bound by its interconnections to appear to be in its essential nature constant for all time. There is a weight to the image, a conviction that radiates authority.

Writing of his Alberta landscapes in *A Painter's Country*, Jackson notes that "The foregrounds are a problem, because so often there is nothing but a few weeds, scrub or stubble get hold of."[28] In *Alberta Rhythm*, he turns this topographical shortcoming to advantage. He first arrests our attention with coarse, multi-hued dabs of paint that pop optically as they race briskly back and forth across a succession of terraces; they recede in size and diminish in contrast the higher they are on the canvas, gradually calming our eyes as they rise suddenly to slip from an

almost white stretch into the broad, enveloping rhythm of the hills. This middle zone is a place for lengthy visual delight, as the warm earth colours flow in closely matched variety amongst the contrasting deep blues of the ridges, touched in their darkest areas with crimson. A wisp of moist green floats across the centre. Finally, we are drawn into the light blue of the sky, but not too deeply, for a delicately articulated cloud layer of warm pinks and mauves causes this third band to slide upward and forward until we sense the ethereal blue dome of the prairie sky. It is altogether a deeply satisfying colour experience, and a compelling, loving evocation of this land that Jackson had come to make his own.

His home was still Toronto, however, where he continued to enjoy a generally acknowledged pre-eminence, even following the return of Fred Varley in 1945. Elsewhere, and particularly in Montreal, the proponents of modernism were in the ascendancy. But even in that city Jackson had his supporters, notably the critic Robert Ayre and, of course, Arthur Lismer. Writing upon the occasion of a retrospective exhibition at the Dominion Gallery there in May 1946, Lismer described Jackson in relation to the new prevailing trends:

> Jackson is not a modern artist. He professes no creed or attachment to any school or 'ism. He is not a city artist, he reflects no studio introspections, no quick decisions to produce a painting in terms of any mechanical, psychological or abstract echo of something theoretic or of some social commentary. This is no reflection on the vitality and meaning of contemporary painting. It means that A.Y. Jackson is not that kind of painter: He has an *out* looking eye not an *in* looking mind. He paints from visual contact with nature, and his selective range and

summarizing technique is amazingly alert and vigorous. It comes from a prodigious experience of analysis and rejection, and of using pigment or the medium of paint as an emotional instrument itself to express the textures, the plastic forms, and the environmental character of things seen. He solves most of his problems on the spot from experience, not from theory or fashion.[29]

Jackson's contribution to Canadian life was recognized officially later in 1946 when he was made a Companion of the Order of Saint Michael and Saint George. He was also elected president of the Canadian Group of Painters for the term 1947–48. But even with such assurances of the importance of his position in the artistic community, he was increasingly aware of the growing numbers of younger artists who must succeed him with their radically different, often opposing ideas. Writing in the foreword of the catalogue of the 1947 CGP exhibition, he called for confidence and tolerance:

> Slowly there is being established in Canada an intelligent and tolerant attitude towards the arts. Confidence in the artists' integrity, whether the painting is traditional or experimental in the field of

25. "A.Y. Jackson Thrilled by Scenery along Alaska Highway — City Visitor," *Lethbridge Herald*, November [?] 1943.

26. Jackson, Regina, to Naomi Jackson, November 1, 1944, quoted in Naomi Jackson Groves, *A.Y.'s Canada*, p. 134.

27. Jackson, Toronto, to Naomi Jackson, Finland, November 21, [1946], quoted in Naomi Jackson Groves, *A.Y.'s Canada*, p. 134.

28. Jackson, *A Painter's Country*, p. 123.

29. Arthur Lismer, "Analysis of the Painter's Work," *A.Y. Jackson, Thirty Years of Painting* (Montreal: Dominion Gallery, 1946), p. 5.

Near Atnick Lake, Northwest Territories 1959
Oil on panel, 26.7 x 34.3 cm
Private collection

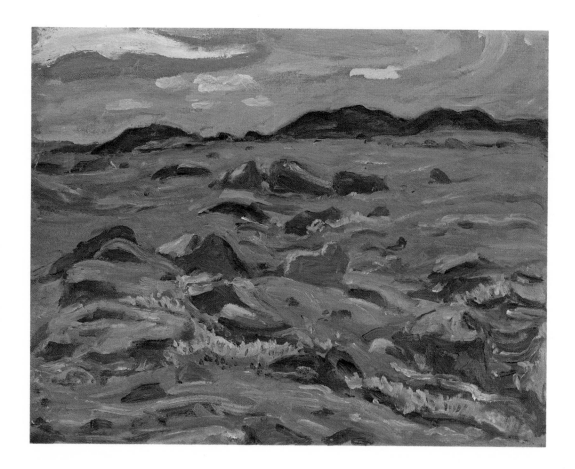

abstract design, is necessary if our artists are to keep abreast of the times.[30]

His call for a middle path at this point in time – the Automatiste's *Refus Global* manifesto had been published in Montreal earlier that year, and there was a growing interest in abstraction in Vancouver, in Calgary, and even in Toronto – would hardly have fooled anyone. It was an intellectual position, and Jackson had never felt comfortable in such stances before.

On the other hand, he did take his prominent role in Canada's artistic community seriously, and that weighed on his time. In a letter to his niece, he explained that he found there were "too many things to do."

> Covering the country both east and west is too much. Eighty-five sketches this year and a lot of canvases; being president of the [Canadian] Group [of Painters], on the council on the Federation [of Canadian Artists], on various committees of the Art Gallery [of Toronto], on the Council of Canadian-Soviet Friendship, and general adviser to artists all over the country....[31]

The following spring proved to be the last that he would work on the North Shore of the St. Lawrence. While there he painted on the smaller-sized panels of the Group of Seven years, as though consciously indulging nostalgia for an era passed. In 1948, for the first time, Jackson undertook two extended sketching trips in the Ottawa-Gatineau region, one during the late winter and a second in early fall. The Ottawa Valley and the Gatineau River and its environs had superceded his familiar favourite grounds in the older settled part of Quebec. Southern Alberta, on the other hand, remained part of his regular pattern of sketching for the next seven years.

The Ottawa connection grew in importance, however, and in 1949 it even opened the way for his return to the Northwest. Jack-son had met Hugh Keenleyside, Deputy Minister of the Department of Resources and Development in Ottawa, and this led to a commission to produce some paintings of the region around Yellowknife on Great Slave Lake. It was arranged that Jackson would fly north on the Eldorado Mine plane from Edmonton in September, following his term at Banff. The Director of the mine suggested that he might like to go right on to Port Radium on Great Bear Lake for a repeat of his visit of eleven years before, and then stop at Yellowknife on his return to fulfil his commission. Jackson jumped at the chance. The Eldorado Mine had been closed down in 1940, but was re-opened under government control for uranium mining in 1942, once the project to develop an atomic bomb was under way. This was his first opportunity to return to a site that had impressed him a great deal on his first visit.

Another Ottawa friend with the department joined him for sketching at Port Radium. Maurice Haycock was a mineralogist and a serious amateur painter whom Jackson had first met on the supply ship *Beothic* returning from the high Arctic back in 1927. Jackson recalls in his autobiography that it was a particularly colourful autumn, and that he and Haycock found many good subjects as they wandered over the hills on and around Labine Point. (See Nos. 40 and 41). Haycock flew south to Yellowknife with him, but soon had to return to Ottawa. The mining recorder in Yellowknife, Geddes Webster, also painted, and he took Jackson around the country; he even arranged a flight to the outlying North Inca gold mine on Indian Lake. As he had eleven years earlier, Jackson stopped at Lethbridge before returning home, and again, as eleven years before, his six-week trip to the Northwest was chronicled in the *Lethbridge Herald*.[32]

The following year, Haycock had business at Port Radium, and Jackson arranged to be there when he was done so that they could sketch together again. This time they were flown out onto the Barren Lands, north of Port Radium. A company plane took Jackson, Haycock, and an employee of Eldorado out August 23, and they were dropped off near the Teshierpi Mountains. It was a desolate yet beautiful land, and its memory was still fresh when he described it in *A Painter's Country*:

> Snow flurries swept over the hills known as the Teshierpi Mountains which protected us from the north. From these hills we could see the Dismal Lakes in the distance. A prospector told me that never were lakes so appropriately named. It was an exciting country; with its moss and lichen and small plants turning red and orange, it looked like a rich tapestry; and big boulders were strewn about everywhere. We could nearly always find one to crouch behind as protection from the east wind when we were sketching.[33]

They stayed until August 28, crawling over the hills, painting and drawing the strange, jagged boulders that littered the whole landscape, boulders that were usually completely covered with richly coloured mosses and lichens. The airplane arrived to take them out earlier than planned, as there were reports of bad weather, and they were back at Port Radium in time for lunch.[34] They stayed to work a bit around the region, and took day

30. A.Y. Jackson, "Foreword," *Catalogue of the 1947 Exhibition of the Canadian Group of Painters* (Toronto: Canadian Group of Painters, 1947).

31. Jackson, Toronto, to Naomi Jackson, Finland, November 21, [1946], quoted in Naomi Jackson Groves, *A.Y.'s Canada*, p. 134.

32. Betty Bletcher, "Noted Artist Urges Creative Work for Young Canadians," *Lethbridge Herald*, October 31, 1949.

33. Jackson, *A Painter's Country*, p. 154.

34. Naomi Jackson Groves, *A.Y.'s Canada*, p. 223.

trips out to interesting spots for sketching. Jackson didn't get the results that he had on the Barren Lands, and near the middle of September they flew out to Yellowknife, and then Edmonton. He went on to Calgary and Lethbridge for further sketching, and worked in southern Alberta until the third week in October.

So taken was he with the Barren Lands that he returned again in 1951, this time with John Rennie of the Giant Yellowknife Mines, another enthusiastic explorer and amateur painter. They set out August 15:

> We flew farther east over the Coppermine River and came down on a lake near September Mountains, sixty miles south of the Coppermine settlement on the Arctic Ocean. It was a lovely country to walk over, with short grass and moss like a carpet, gently rolling hills with occasional rock outcrops and many little lakes. It appeared treeless, but in sheltered spots we found a few stunted spruce trees. The trees that die last for years and these provided us with excellent firewood.
>
> The plane picked us up after a week, and we flew west to Hunter Bay, close to Great Bear Lake, a much rougher country, with bold escarpments back from the shore. From the plane it looked like easy country to travel over; there appeared to be long stretches of gravel resembling highways. When we actually got on them, they turned out to be miles of large sharp stones covered with lichen.[35]

They camped at Hunter Bay from August 20 until about the end of the month, and this is where Jackson got most of his best sketches. They then flew to Port Radium, and from there on September 7 to Coppermine on the Arctic coast; the following day it was back south and west to Fort Franklin, a Hudson's Bay post at the end of the southwest arm of

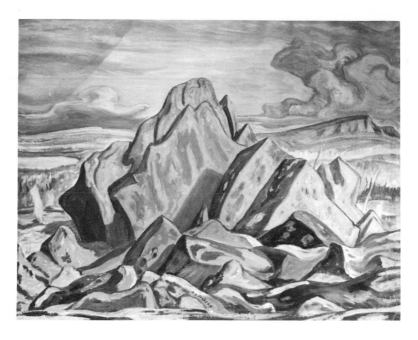

FIG. 2
Hills at Great Bear Lake, c. 1953
Oil on canvas,
96.5 x 127.6 cm
Art Gallery of Hamilton, gift of the Women's Committee, 1958.

Great Bear Lake. Jackson stayed there three days, and then travelled on an ore barge down the Great Bear River, which empties into the Mackenzie at Fort Norman. He didn't go that far, but stopped at a portage camp for a few days, and from there was flown to Yellowknife, arriving September 20. As usual, he went on to southern Alberta, sketching and visiting until about the middle of October.

Those three successive journeys to Great Bear Lake and the Barren Lands resulted in some of the finest sketches of Jackson's career. Viewed as a group, they are unrivalled. The primeval nature of the landscape appealed to him, with its vigorous midsummer life clinging tenaciously to the margins of existence. Nothing extraneous survives. Fundamental values seem clear.

During this period of travel to the Northwest, Jackson produced a number of paintings for the federal Department of Resources and Development, all small or medium-sized canvases. Ten are now owned by Eldorado Nuclear Limited. A number are attractive, and most are sensitively handled studies of different mines and settlements in the Yellowknife and Port Radium districts. However, they display none of the feeling of wholeness, of completeness, that we sense before the wilderness sketches.

Jackson produced as well at least two large canvases for public display. *The Great Lone Land, Eldorado*, which he exhibited with the CGP in Toronto late in 1950 and in Montreal early in 1951, has disappeared from public view. (See No. 40.) The other is in the collection of the Art Gallery of Hamilton, where it is called *Hills at Great Bear Lake*. (See fig. 2.) Jackson apparently valued this picture highly. It is a synthesis, a grand summation of the power he felt in that primitive land. In that sense it is symbolic, and with

its dominating central rocky image, displayed almost as an object of veneration, it is an icon; Jackson's *Jack Pine* or *West Wind* in the land of no trees.

Hills at Great Bear Lake is, nonetheless, disappointing in the light of the sketches that are behind its conception. Its colour is generalized, yet still self-conscious, with a rather obvious contrast of pinkish-red and green dominating. The forms of the rocks seem arbitrary, not at all the consequence of powerful glacial forces, as is so evident in the sketches. Even the title is diffuse, imprecise. The painting depicts not hills (although it is a scene in the hills), but the large glacial boulders like those that were so plentiful near the Teshierpi Mountains. It was, in fact, called *The Great Northland* in the late 1950s.[36]

The canvases to value from the Great Bear Lake and Barren Lands trips are rather the medium-sized pictures that adhere closely to both the form and the spirit of the sketches, paintings like *Hills at Hunter Bay, Great Bear Lake* (No. 48), that cling loyally to local colour and the coarse, vibrant texture of the region. Like *Mountains on the Alaska Highway* of eight years earlier, such pictures show no concern for the taste of the time, holding true to an inner vision that grew from intense concentration on the visual force of the land. It is highly personal art, and would be increasingly the direction of Jackson's inclination.

There were many signs of change as Jackson approached seventy. *Hills at Great Bear Lake* is one of the last of the large, emblematic crowd-pleasers that he periodically produced, along the lines of those shown at the CNE just prior to the war. The display of this large Hunter Bay canvas at the CNE in 1953 marked the last time that he would submit work for exhibition there, and he stopped showing with the OSA quite abruptly after 1952, breaking a continuous record of seventeen years.[37] He exhibited with the CGP

in 1952, in 1954 (There was no show in 1953), and for the last time in 1955. He had been elected president again for 1953–54. He showed one work each for a couple of times with the RCA in the mid-1950s (He accepted re-instatement as an Honourary Member in 1956), but this was fence-mending. He was no longer interested in painting for the shows.

Not that he stopped painting exhibitable canvases. There are many of 1951–53 and beyond that have all of his well-known qualities of colour and form, and that are full of the life of southern Alberta (see No. 49), of Quebec (see No. 50; No. 51, Pl. No. 4), or of Georgian Bay (see No. 57). His sketching abilities, too, held strong. He broke routine in 1954, and spent the spring in the West, a trip that resulted in a particularly luscious group of sketches. And Georgian Bay, always a favourite summer haunt, proved extraordinarily fruitful for sketching in the early 1950s.

Jackson's withdrawal from the annual shows coincided with the beginnings of Painters Eleven in Toronto, and with the ascendancy of abstract painting that their success represented. It coincided as well with his major retrospective exhibition organized by the Art Gallery of Toronto; held there in October and November 1953, it was then shown at the National Gallery of Canada, the Montreal Museum of Fine Arts, and the Winnipeg Art Gallery. No finer tribute could he possibly have claimed, although such an exhibition demonstrated that there was much more work behind him than yet could come, and in defining his contribution, a retrospective seemed to remove it from contemporary relevance.

He was puzzled that younger painters seemed not to be moved and inspired by the wild country as he was, and he could not help resenting whatever it was they seemed to pursue instead. He knew that no matter what

honours now came his way (there was an LL.D., his second, from McMaster University in Hamilton in 1953, and there would be four more over the following fourteen years), they would add little to his stature in the community of younger Toronto artists. His voice was hardly heard in that lively forum. It was not so confusing a period as had been the early and mid 1930s. He did not feel, as he had then, that his life in Toronto was a great knot. He knew what he had when he was sketching on the Barren Lands, and he had no doubts of its value. It required only the decision to turn to that part of his life more often, to embrace it, if he could.

Lawren Harris sold the Studio Building in 1948 (a decisive step at the time of *his* big retrospective at the Art Gallery of Toronto), but Jackson stayed on, as did most of the tenants, at least for a while. A new landlord had to make a difference, however, and various changes around the building – the only Toronto home Jackson had known in forty years – finally forced his decision to leave. In August 1954 he bought a small piece of property next to that of his niece, Constance Hamilton, at Manotick, near Ottawa, and had a live-in studio built. He was settled in by the third week of March 1955.

About the time that Jackson purchased land at Manotick, he visited the east shore of Lake Superior near Wawa for the first time in years; he stayed with friends from Toronto, Professor and Mrs. H.U. Ross, who kept a summer home there. The following August he

35. Jackson, *A Painter's Country*, p. 155.

36. It is so identified on a photograph sent to the Art Gallery of Toronto late 1957 or early 1958 by the Watson Galleries, Montreal, offering the painting for sale. Now in the artist's file, Reference Library, Art Gallery of Ontario, Toronto.

37. Toronto, CNE, August 28–September 12, 1953, No. 50, as "Landscape at Hunter Bay," and subsequently in *Jackson 1953*, Winnipeg only, March 14–April 4, 1954, No. 241, with the measurements reversed.

Windy Day, Clontarf, Ontario 4 July 1964
Oil on panel, 26.7 x 34.2 cm
Art Gallery of Greater Victoria (64.114)

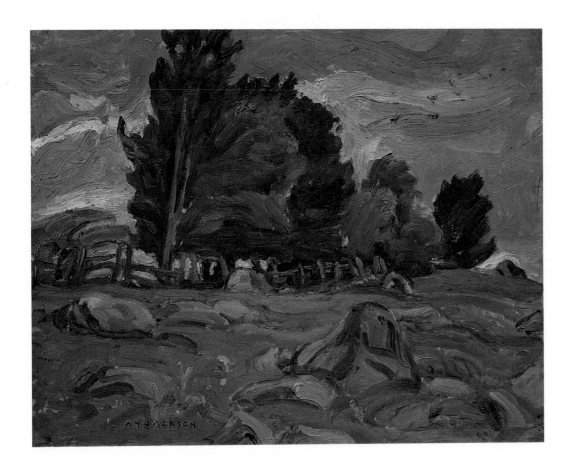

Camp Beach Looking East July 1965
Oil on panel, 26.7 x 34.3 cm
Private collection

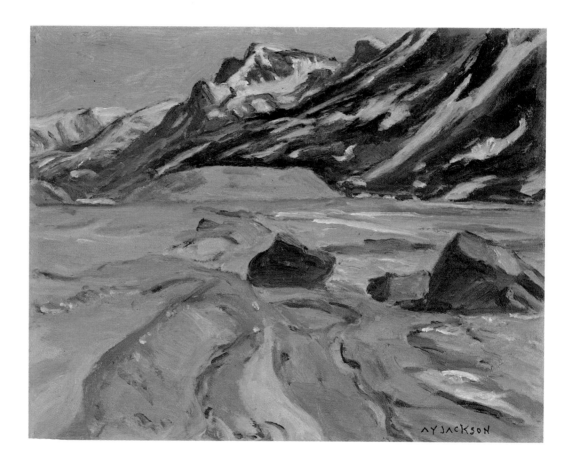

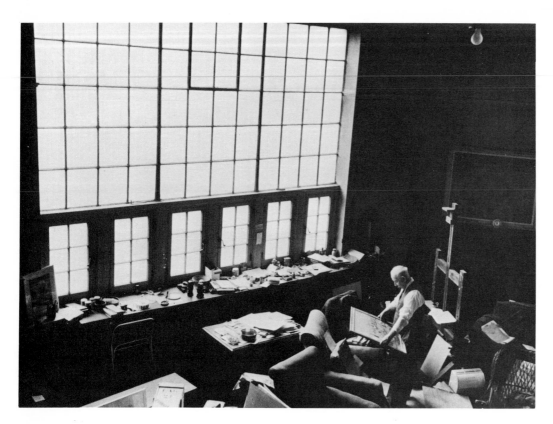

FIG. 3
Preparing to leave the Studio Building, Toronto, January 1955.

The bulk of these were small, sketch-like paintings, in the making of which he was able to recapture to a large degree his acute perception of the colour, mood, and texture, the real ambience of those places that he sought to know. In such canvases as *MacIntosh Bay, Lake Athabasca, Saskatchewan* (No. 60), his palette in particular set his work apart from that of any other painter of his day. Yet this was not remarked at the time and likely was not noticed, not even by Jackson.

The following year, 1958, was doubtless consumed largely in the final preparations of *A Painter's Country*, the first edition of which appeared in November. All of his sketching that year – in the Ottawa Valley, at Morin Heights in the Laurentians north of Montreal, at Georgian Bay, and in the Eastern Townships – was within easy distance of Manotick.

Maurice Haycock got him back to the Northwest in 1959. Near the end of August they flew into Uranium City on Lake Athabasca and, after working for a short while, they flew north and west to Great Slave Lake and Yellowknife, then north to Port Radium on Great Bear Lake. From there they flew to Hornby Bay, and to Atnick Lake and Lake Rouvière in the Barren Lands between the Teshierpi Mountains and the Dease River. They camped for a week at Lake Rouvière, and Jackson brought back wonderful pieces from there and Atnick Lake, rich, vibrant colour studies of the visually remarkable country. Seven years later, he recalled the country around the Lake Rouvière camp for a friend in Ottawa:

> . . . the reflection of the sky on the water, the mix of living and dead matter, the shrubbery and the rocks, the dwarf trees and the dark crevices in the ground, the berry bushes and the deadwood strewn where it fell, some of it some fifty years ago. . . . The freezing of the lakes may start

bought some property with them on Twidale Bay at Wawa, and had a small cabin built for himself. Lake Superior joined Georgian Bay and the Ottawa-Gatineau region as part of his annual routine of travel and sketching. Southern Alberta hardly saw him after 1954.

The Barren Lands still beckoned, however. Maurice Haycock, with whom he sketched regularly around Ottawa, Haycock's home, was able to arrange another flying visit in the early autumn of 1957. They took the usual route by air from Edmonton to Yellowknife, and arrived August 28. They were soon out on

the Barren Lands, but not for very long. Haycock then arranged for them to be flown south and east to Gunnar Mines near Uranium City on the north shore of Lake Athabasca, just inside the Saskatchewan border. They seemed to have been always on the move, and Jackson brought back only a few good sketches.

By this time he was not exhibiting at all; but through his government and mining connections, friendly agents, and some dealers, he was selling most of his sketches and virtually all the canvases he produced.

before the summer is out but surely before the fall has had time to shower the countryside with a mantle of brilliant colours – red, yellow, and purple.[38]

Working from about 7:30 in the morning to 5:30 at night, with a short break for lunch, he produced two or three sketches a day. Near the end of the second week of September they took a plane from Port Radium to Bathurst Inlet, a small settlement far north and east on the Arctic Ocean. Jackson made his way to Lethbridge by September 27.

He later painted a large canvas from one of the best of the Lake Rouvière sketches (No. 64). *Lake Rouvière* (No. 65), in the Firestone Art Collection in Ottawa, is one of the last big canvases. It has all of the characteristics of the late work, the free, sketch-like handling, the delight in various textures, from coarse grit to silky smoothness, and the strange, intense colours. The colours are unforgettable. Strident, but in close harmony, they call the tune for a dream-like dance, as the twisting forms and rippling contours celebrate the cycle of survival.

Jackson took it easy the following year, working only around his home grounds – in the Ottawa area in the spring and fall, on Lake Superior at Wawa in July, and on Georgian Bay in August. In the early summer of 1961, from May 27 to June 15, Haycock took him to a new mining area on the Quebec-Labrador border, where they sketched around Schefferville and Carol Lake. They flew in again the following June and, two years later, in 1964, Haycock arranged what was to be Jackson's last trip to the Northwest.

Jackson flew to Whitehorse with another Ottawa sketching partner, Ralph Burton; there they met Haycock, September 11. They rented a station wagon, and set off on the Alaska Highway, along the route he had travelled twenty-one years before. They passed

Kluane Lake and, running on northwest, entered Alaska. At Tetlin Junction they cut back east, but continued north as far as Eagle, where they recrossed into the Yukon and finally reached Dawson City. It had taken ten days. They used Dawson as a base for another ten days, while they visited some outlying areas. They spent two days in the Ogilvie Mountains to the north, and some time at Keno Hill, to the east. (As always when he travelled with Maurice Haycock, Jackson was the guest of a large mining company.) They then headed south and made their way by a more direct route back to Whitehorse. Jackson celebrated his eighty-second birthday there before returning home.

So much moving about was not really conducive to good sketching. The very finest of the late sketches, those done in the early sixties when he was around eighty, tend to be of more familiar areas – the Ottawa Valley, Lake Superior, Georgian Bay – although there is a hauntingly lovely, organic study of the *Indian Church at Brantford, Ont.* done in April 1963 (No. 68).

Jackson had one goal in his sketching, to mark down as exactly as possible the light, colour, form, and texture of a place. The fact that throughout his career he often made a pencil drawing as well as an oil sketch for aid in later working up a canvas underscores the absence of drawing in the sketches. They are essentially studies of mass and tone, and always reveal an exceptional sensitivity to local colour. This foundation of his art goes back to William Brymner's classes in Montreal just after the turn of the century, and was reinforced by his study in France shortly after. In his later sketching he seems to become more and more particular in his close observation of texture and atmosphere, as well as in his exact, physical response to form. Each image increasingly is conceived as a continuum, the fluid passage from form into form eased by

countless subtle observations of the more-or-less comfortable union of all things in nature. It is perceived as in acute balance, however, and never more so than in the sketches from the far North.

Jackson, in a dream come true, managed to get to the far North one more time, and far north, to Baffin Island in the High Arctic. He had already been there twice, in 1927 and 1930 by boat, but in July 1965 he and his niece Geneva and her friend Una (Jackson as expedition artist, the women as camp cooks) flew in with eleven members of the Alpine Club of Canada and a young doctor who is also a painter, Jim MacDougall of Montreal. They stopped at Frobisher Bay, but camped at Pangnirtung Pass, north of Cumberland Sound, and while the others climbed, Jackson painted. He did wonderfully well. He entered completely the deep nature of this land of rock and ice and gravel. He felt its life. The visions he brought back grow slowly before our eyes, gritty and dark, yet clear. The authenticity of mood and atmosphere – the sense of the climate, of the sharp air and smudges of floating fog or cloud – is overwhelming, a triumph.

That fall Jackson suffered considerably from a condition that was diagnosed as Meunier's Syndrome, resulting in bouts of dizziness. He spent ten days in hospital recovering. Back in 1962, it had been determined that he had diabetes, and at that time he began to control his diet and, to some degree, his activities. He moved to Ottawa, to make things easier, and to be near friends. After 1965 he had to watch his health much more closely, but he still kept sketching throughout the usual seasons, although almost exclusively in the immediate Ottawa area or on Georgian Bay, where he continued to summer until 1967.

38. Firestone, *The Other A.Y. Jackson*, p. 198.

Jackson went on at least two sketching trips with Ralph Burton in late March and early April 1968, staying in Ripon and in Grenville with friends. But perhaps the best sketch of the season was made on a sunny day in late February, when good friends in Buckingham drove him up the road to Notre Dame de la Salette, and watched as he painted this favourite subject for what turned out to be the last time. As late as April 19-21 he travelled to and from Toronto by overnight bus, to attend a young cousin's wedding. On the afternoon of Monday, April 22, the day he arrived at the Ottawa terminal at 5:00 AM and walked six blocks to his studio, he suffered a gradual stroke that resulted in partial paralysis. Although he later handled his painting tools, he had no control. That shimmering vision of Notre Dame de la Salette stands as the final testament to a life shaped by the relentless exercise of the union of hand and eye.

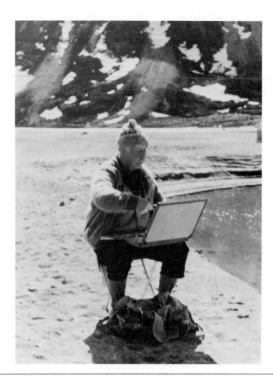

FIG. 4
Up behind Pangnirtung, Baffin Island, July 1965.

Abbreviations

AAM
Art Association of Montreal, annual spring show catalogue.

AGO Canadian Collection
Hellen Pepall Bradfield, *Art Gallery of Ontario, The Canadian Collection* (Toronto: McGraw-Hill Company of Canada Limited, 1970).

A Painter's Country
A.Y. Jackson, *A Painter's Country* (Toronto: Clarke, Irwin & Company Limited, revised "Centennial Edition," 1967).

A.Y.'s Canada
Naomi Jackson Groves, *A.Y.'s Canada* (Toronto/ Vancouver: Clarke, Irwin & Company Limited, 1968).

CGP
Canadian Group of Painters, exhibition catalogue.

CNE
Canadian National Exhibition, Toronto, Department of Fine Arts, annual exhibition catalogue.

Jackson 1953
Toronto, Art Gallery of Toronto, *A.Y. Jackson Paintings 1902-1953*, October – November, 1953 and national tour.

Jackson 1960
London, London Public Library and Art Museum, *A.Y. Jackson — The Canadian Landscape*, January 29 – February 20, 1960; also shown at Hamilton, Art Gallery of Hamilton, *A.Y. Jackson, A Retrospective Exhibition*, March – April, 1960. A catalogue was published in Hamilton.

NGC Canadian School
R.H. Hubbard, *The National Gallery of Canada Catalogue of Paintings and Sculpture, Volume III: Canadian School* (Toronto: University of Toronto Press, 1960).

NJG
Naomi Jackson Groves inventory number.

OSA
Ontario Society of Artists, Art Gallery of Toronto, annual exhibition catalogue.

RCA
Royal Canadian Academy of Arts, annual exhibition catalogue.

1

Artists' Camp on the Western Islands,
Georgian Bay c. 1933

Graphite on paper, 22.7 x 30.3 cm

Inscribed lower right: *Western Islands*

NJG 278r

Art Gallery of Ontario, Toronto,
purchased 1980 (80/15)

PROVENANCE
Gift of the artist c.1969. Dr. Naomi Jackson Groves,
Ottawa.

LITERATURE
A.Y.'s Canada, pp.108, 238, repr. pl.50, p.109.

There is another drawing verso: *Georgian Bay Islands*
with Diagonal Tree; inscribed centre right margin: *AY*
+ Frank Br-.

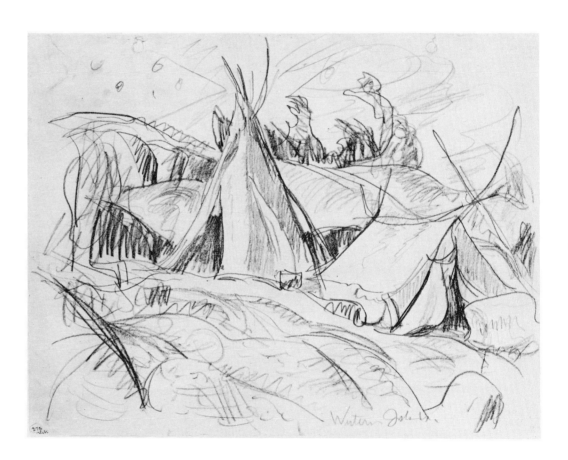

2

Valley of the Gouffre River 1933

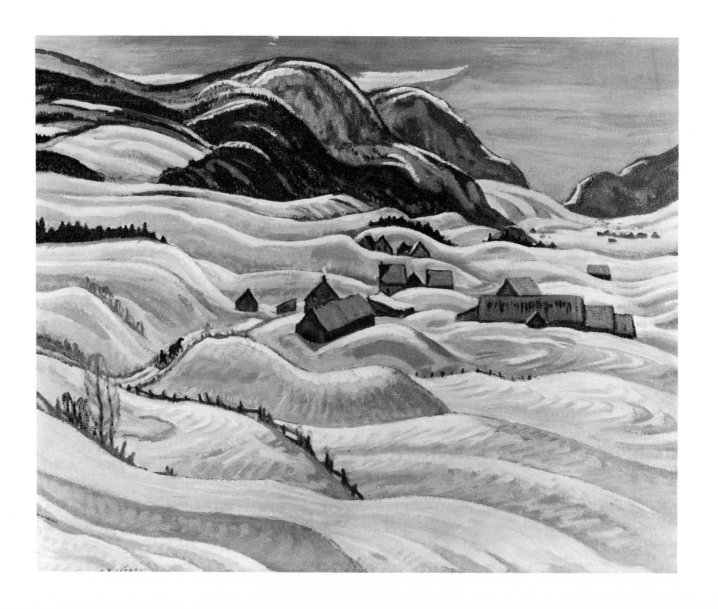

Algoma, November 1934

Oil on canvas, 64.0 x 81.8 cm

Signed and dated lower left: A Y JACKSON/33

NJG 2351

The McMichael Canadian Collection, Kleinburg,
Ontario, gift of Anne Savage, Montreal, 1968

PROVENANCE
Acquired from the artist c.1934 by Anne Savage,
Montreal.

LITERATURE
McMichael 1970, repr. twice. Subsequent
McMichael Collection catalogues to *McMichael
1979*, p.184, repr., repr. in colour p.37.

EXHIBITIONS
Toronto, The Galleries of J. Merritt Malloney,
Paintings by A.Y. Jackson, until March 10, 1934, No.20.
51st *AAM*, April 19 – May 13, 1934, No.154. *Jackson
1953*, No.54.

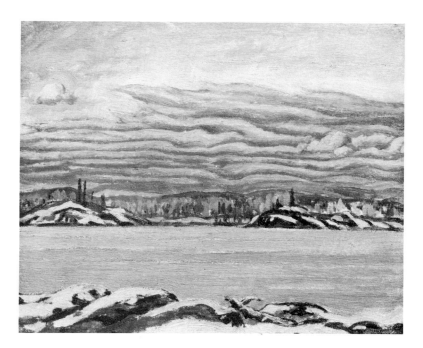

Oil on panel, 27.3 x 34.9 cm

NJG 2352

The McMichael Canadian Collection, Kleinburg,
Ontario, gift of Mr. and Mrs. R. McMichael, 1966

LITERATURE
McMichael 1967, repr. twice. Subsequent
McMichael Collection catalogues to *McMichael
1979*, p.184, repr., repr. in colour p.45.

EXHIBITION
Washington, The Phillips Collection, *Group of Seven
Canadian Landscape Painters*, January 22 –
February 20, 1977, No.27, repr. in colour.

The canvas is in this exhibition, No.4.

4

Algoma, November 1935

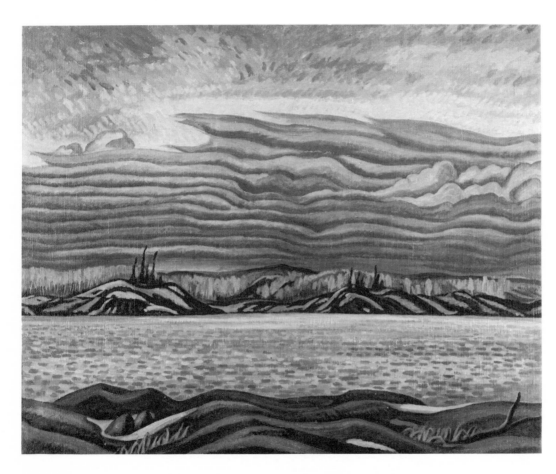

Oil on canvas, 81.3 x 102.1 cm

NJG 2353

The National Gallery of Canada, Ottawa,
gift of H.S. Southam, C.M.G., LL.D., Ottawa, 1945 (4611)

PROVENANCE
Acquired from the artist 1935.

LITERATURE
Walter Abell, "Canadian Aspirations in Painting,"
Culture III (1942): repr. fig. 2. Graham C. McInnes,

Canadian Art (Toronto: The Macmillan Company of
Canada Limited, 1950), repr. in colour. H.O. McCurry,
"The Emerging Art of Canada," *United Nations World*
(July 1950): repr. p.67. "A.Y. Jackson – A
Retrospective Exhibition," *Canadian Art* XI (Autumn
1953): repr. p.5. A.Y. Jackson, "Box-car Days in
Algoma, 1919-20," *Canadian Art* XIV (Summer 1957):
repr. p.141. *NGC Canadian School*, p.140, repr. J.
Russell Harper, *Painting in Canada, A History*
(Toronto: University of Toronto Press, 1966), repr. in
colour pl.272, p.302. Peter Mellen, *The Group of
Seven* (Toronto/Montreal: McClelland and Stewart
Limited, 1970), repr. pl.267, p.215. Dennis Reid, *A
Concise History of Canadian Painting* (Toronto:
Oxford University Press, 1973), p.175, repr. p.176.

EXHIBITIONS
Montreal, W. Scott and Sons, *A.Y. Jackson Exhibition*,
November 16 – 30, 1935, No. 3. Toronto, Art Gallery of
Toronto, *CGP*, January 1936, No.47. Ottawa, The
National Gallery of Canada, *Retrospective
Exhibition of Painting by the Group of Seven, 1919 –
1933*, March 1936; Art Association of Montreal, until
May 5, 1936; Art Gallery of Toronto, May 15 – June 15,
1936, No.119, repr. London, Royal Institute Galleries,
*Exhibition of Paintings Drawings and Sculpture by
Artists of the British Empire Overseas*, May 8 – 29, 1937,
No.22. Liverpool, Walker Art Gallery, *The Sixty-third
Autumn Exhibition*, October 16, 1937 – January 8,
1938, No.498. New Haven, Yale University Art Gallery,
Canadian Art 1760-1943, March 11 – April 16, 1944, no
No. *Jackson 1953*, No.60. Bordeaux, "Le Mai de
Bordeaux," *L'art au Canada*, May 11 – July 31, 1962,
No.46, repr. pl.XVII. Victoria, Art Gallery of Greater
Victoria, *Ten Canadians – Ten Decades*, April 25 –
May 14, 1967, No.17. Spokane, International
Exposition, *Our Land, Our Sky, Our Water*, May 4 –
November 3, 1974, No.116. Ottawa, The National
Gallery of Canada, *Canadian Painting in the
Thirties*, 1975, also national tour, No.7, pp.27, 154,
repr. p.35.

The oil sketch is in this exhibition, No.3.

5

March Afternoon, St. Tite des Caps March 1937

6

St. Tite des Caps April 1937

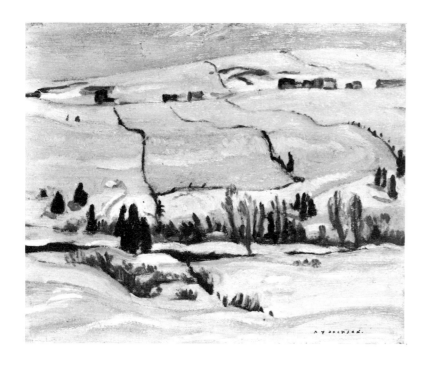

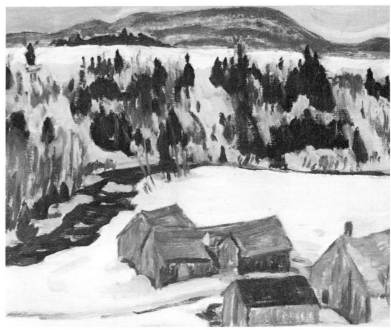

Oil on panel, 21.6 x 26.7 cm

Signed lower right: A Y JACKSON

NJG 24

Private collection

PROVENANCE
Gift of the artist c.1938.

There is an oil sketch of sunflowers verso, probably
done near Brockville, Ontario.

Oil on panel, 21.2 x 26.0 cm

Signed on verso: *A.Y. Jackson*

NJG 2226

Private collection

PROVENANCE
Acquired from the artist 1938. By descent to the
present owners.

7

St. Tite des Caps c. 1937

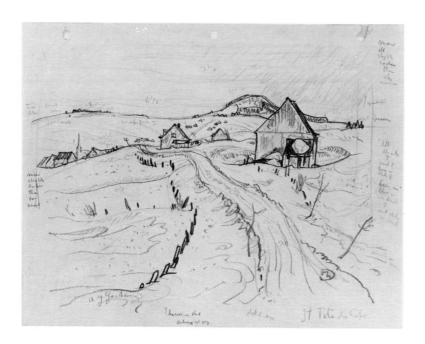

Graphite on paper, 19.7 x 26.7 cm

Signed lower left: *A.Y. Jackson*;
inscribed lower right: *St. Tite des Caps*;
in various locations with colour notations.

NJG 374

Art Gallery of Ontario, Toronto,
gift of the McLean Foundation, 1963 (62/56)

PROVENANCE
Acquired from the artist. Purchased from Galerie
Dresdnere, Toronto, 1963.

LITERATURE
AGO Canadian Collection, p.205.

EXHIBITIONS
Toronto, Galerie Dresdnere, *Jackson Drawings 1908-
30*, from March 16, 1963, no No. Toronto, Art Gallery
of Toronto, *Drawings*, September – October 1963, no
No., p.6.

8

Drought Area, Alberta October 1937

Oil on panel, 26.7 x 34.1 cm
Signed lower right: A Y JACKSON.

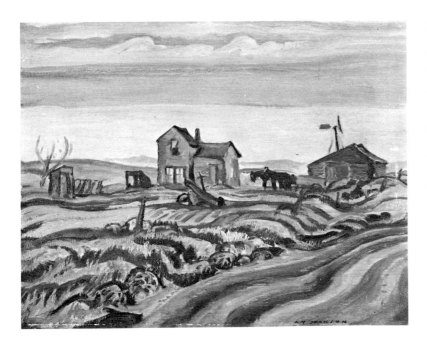

NJG 2355

The National Gallery of Canada, Ottawa,
purchased 1939 (4539)

PROVENANCE
Acquired from the artist.

LITERATURE
NGC Canadian School, p.139. *A.Y.'s Canada*, p.140.

The work is titled and dated verso. There is a related
drawing in a private collection, repr. pl.66, *A.Y.'s
Canada*, p.141.

9

Lundbreck, Alberta November 1937

Oil on panel, 26.4 x 34.3 cm
Signed lower right: A.Y. JACKSON.

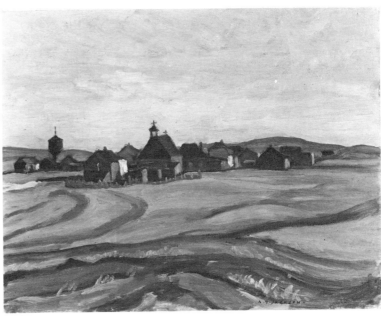

NJG 2356

Art Gallery of Ontario, Toronto,
gift from the J.S. McLean Collection, on loan from the
Ontario Heritage Foundation, 1970 (L69.25)

PROVENANCE
Acquired from the artist c.1938.

EXHIBITION
Toronto, Art Gallery of Ontario, *The J.S. McLean
Collection of Canadian Painting*, September 19–
October 20, 1968, and national tour until October 26,
1969, No.36.

The work is dated and titled verso, and inscribed:
reserved. J.S. McLean. A drawing of the same subject
is in the McCord Museum, Montreal, repr. pl.65 in
A.Y.'s Canada, p.139.

10

Mokowan Butte 1937

Oil on panel, 26.0 x 34.2 cm

Signed lower right: A Y JACKSON.

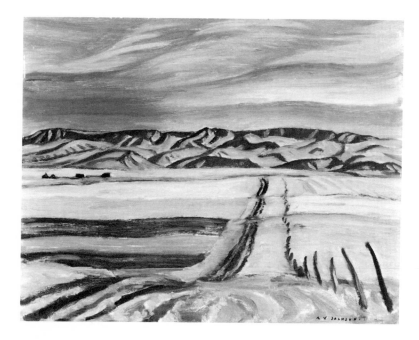

11

Blood Indian Reserve, Alberta 1937

Graphite on paper, 21.9 x 28.6 cm

Signed lower right: *A Y Jackson*; inscribed lower left: *Blood Indian Reserve*; and with numerous scattered colour notations

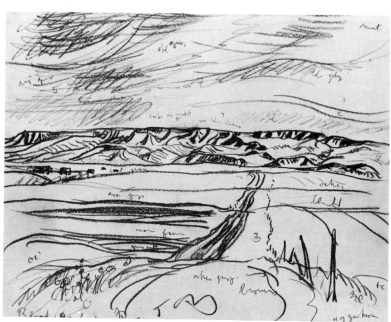

NJG 2357

Art Gallery of Ontario, Toronto,
gift from the J.S. McLean Collection, on loan from the
Ontario Heritage Foundation, 1970 (L69.24)

PROVENANCE
Acquired from the artist c.1938.

LITERATURE
A Painter's Country, p.124.

EXHIBITION
Toronto, Art Gallery of Ontario, *The J.S. McLean
Collection of Canadian Painting*, September 19 –
October 20, 1968, and national tour until 26 October
1969, No.35.

The McLean catalogue records an old label on the
back with a pencil diagram of the location of
Mokowan Butte, inscribed: *On Blood Indian
Reserve/Site of Sun dances and clay for war
paint/F.G. Cross*. There is a virtually complete oil
sketch of a southern Alberta landscape on the back.
Mokowan Butte is the sketch for a canvas in this
exhibition, No.12. A related drawing is No.11.

NJG 1236r

The McMichael Canadian Collection, Kleinburg,
Ontario, gift of Mrs. Robert McMichael, 1974

PROVENANCE
Acquired from the artist c.1969.

LITERATURE
A.Y.'s Canada, pl.64, p.137. *McMichael 1970*, repr.
Subsequent McMichael Collection catalogues to
McMichael 1979, p.186, repr.

The canvas is in this exhibition, No.12. A related oil
sketch is No.10.

12

Blood Indian Reserve, Alberta c. 1937

Oil on canvas, 63.8 x 81.3 cm

Signed lower right: A Y JACKSON

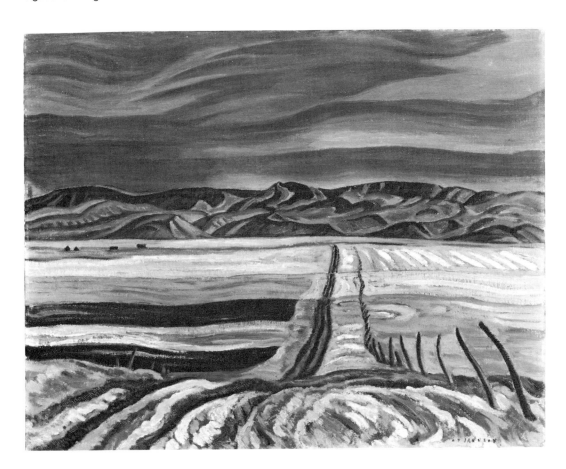

NJG 2358

Art Gallery of Ontario, Toronto,
purchased 1946 (2828)

PROVENANCE
Acquired from the artist.

LITERATURE
A.Y.'s Canada, p.136. Peter Mellen, *The Group of Seven* (Toronto/Montreal: McClelland and Stewart Limited, 1970), repr. pl.221, p.193. *AGO Canadian Collection*, p.211.

EXHIBITIONS
CNE, August 22 – September 6, 1952, No.70. *Jackson 1953*, No.62, repr. pl.13. Edmonton, Edmonton Art Gallery, *Art in Alberta: Paul Kane to the Present*, April 6 – May 10, 1973, also Calgary, Glenbow-Alberta Institute, July 1 – August 25, 1973, no No., repr. Ottawa, The National Gallery of Canada, *Canadian Painting in the Thirties*, 1975, also national tour, No.8, pp.28, 154, repr. p.35. Edmonton, Edmonton Art Gallery, *Painting in Alberta, An Historical Survey*, July 11 – August 31, 1980, No.49.

The oil sketch is in this exhibition, No.10, as is the drawing, No.11.

13

Alberta Foothills 1937

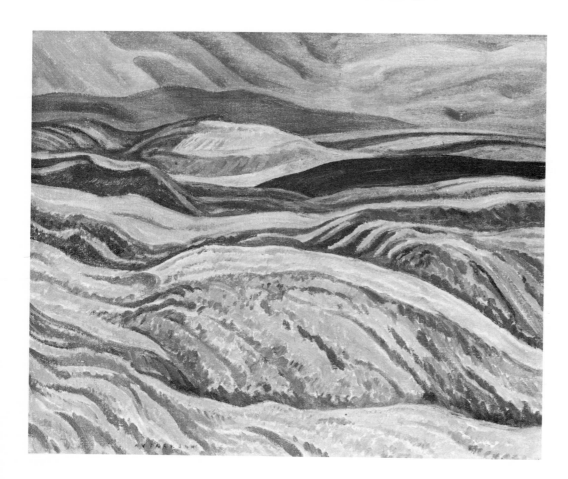

Oil on canvas, 64.0 x 81.2 cm

Signed lower left: A Y JACKSON

NJG 2359

The McMichael Canadian Collection, Kleinburg, Ontario, gift of Mr. and Mrs. Robert McMichael, 1971

PROVENANCE
J.J. Vaughan, Toronto, by 1948.

LITERATURE
McMichael 1967, repr. twice. Subsequent McMichael Collection catalogues to *McMichael 1979*, p.184, repr., and repr. also p.48. Paul Duval, *Four Decades, The Canadian Group of Painters and their Contemporaries – 1930 –1970* (Toronto/Vancouver: Clarke, Irwin & Company Limited, 1972), repr. p.16.

EXHIBITIONS
66th *OSA*, March 1938, No.95, ill. p.6, as "Alberta." *CNE* August 27 –September 11, 1948, No.29 as "Alberta."

14

Early Snow, Alberta c. 1937

(SEE COLOUR PLATE NO 1)

Oil on canvas, 82.5 x 116.8 cm

Signed lower left: A Y JACKSON

NJG 2360

Kenneth G. Heffel Fine Art Inc., Vancouver

PROVENANCE
Acquired from the artist before 1943. Norah de Pencier, Owen Sound, Ontario. Sotheby Parke Bernet (Canada), Toronto, October 18, 1976, lot 78, repr. p.47 and colour cover. Purchased by The Art Emporium, Vancouver. George Clarke, Vancouver c.1978 (the Fannin Hall Collection). Acquired by the present owner 1979.

EXHIBITIONS
Toronto, Art Gallery of Toronto, *Exhibition of Contemporary Canadian Arts*, March 3 – April 16, 1950, No.75. Vancouver, Kenneth G. Heffel Fine Art Inc., *The Group of Seven and Their Contemporaries*, February 29 – March 22, 1980, No.91, repr. in colour.

The work is titled on a label attached to the stretcher. There is an oil sketch in a private collection, Vancouver, inscribed verso: *Snow in September, Bar X Ranch, near Pincher Creek/Sept. 20, 1937/Donald Buchanan*.

15

Porcupine Hills, Alberta October 1938

Oil on panel, 26.7 x 34.3 cm

Signed lower right: A Y JACKSON

NJG 2361

The National Gallery of Canada, Ottawa, purchased 1939 (4535)

PROVENANCE
Acquired from the artist.

LITERATURE
NGC Canadian School, p.139, repr.

EXHIBITIONS
Jackson 1953, No.219. Geneva, Musée d'Art, *Art et travail*, 1957, No.94 in Canadian section.

The work is titled and dated verso.

16

Eldorado Mines, Labine Point
September 1938

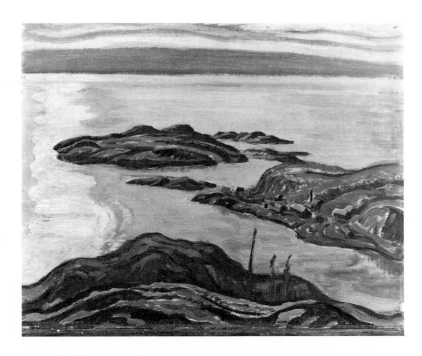

Oil on panel, 26.4 x 34.1 cm

Signed and dated lower right: A Y JACKSON/'38

NJG 2362

The National Gallery of Canada, Ottawa,
purchased 1939 (4537)

PROVENANCE
Acquired from the artist.

LITERATURE
NGC Canadian School, p.139.

EXHIBITION
Jackson 1953, No.221.

The work is titled and dated verso. The canvas was
exhibited 67th *OSA*, March 3–29, 1939, No.76, repr.
p.14, then collection of Gilbert LaBine.

17

Lake at Labine Point, Great Bear Lake
September 1938

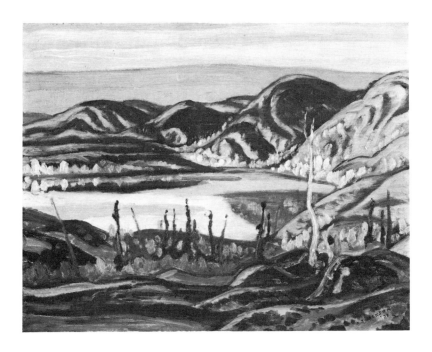

Oil on panel, 26.0 x 35.3 cm

Signed and dated lower right: A Y JACKSON/'38

NJG 2363

Art Gallery of Ontario, Toronto,
purchased 1940 (2538)

PROVENANCE
Acquired from the artist.

LITERATURE
AGO Canadian Collection, pp.211-12.

The work is dated and titled verso, and in addition
inscribed: *Arctic Lake*.

Pre-Cambrian Hills 14 September 1938

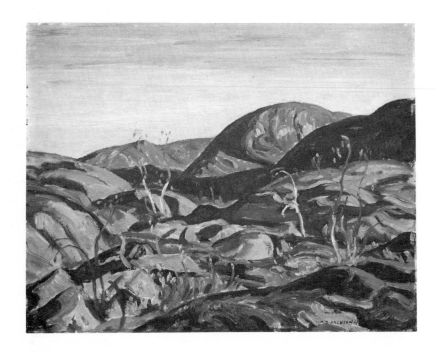

Oil on panel, 26.5 x 34.1 cm

Signed lower right: A Y JACKSON

NJG 2364

The National Gallery of Canada, Ottawa,
purchased 1939 (4543)

PROVENANCE
Acquired from the artist.

LITERATURE
NGC Canadian School, p.140.

The work is titled and dated verso. The canvas is in
this exhibition, No.19.

Oil on canvas, 71.5 x 91.4 cm

Signed and dated lower right: A Y JACKSON/1939

NJG 2365

Art Gallery of Ontario, Toronto,
purchased 1946 (2829)

PROVENANCE
Acquired from the artist.

LITERATURE
Canadian Review of Music and Art I (November
1942): repr. p.13. Donald W. Buchanan, *Canadian
Painters: From Paul Kane to the Group of Seven*
(Oxford: Phaidon Press, 1945), repr. pl.50. *AGO
Canadian Collection*, p.212, repr. *A.Y.'s Canada*,
p.218. Peter Mellen, *The Group of Seven*
(Toronto/Montreal: McClelland and Stewart Limited,
1970), repr. pl.222, p.193.

EXHIBITIONS
CNE, August 25 – September 9, 1939, No.113, repr.
p.32. Toronto, Art Gallery of Toronto, *Holgate,
Jackson, Lismer and Newton*, April 1940, no No. Paris,
Musée d'art moderne, *UNESCO, Exposition
internationale d'art moderne*, 1946, No.16. Windsor,
Willistead Art Gallery, *The Group of Seven*,
November 1948, No.12. *CNE*, August 22 – September
6, 1952, No.69. Toronto, Art Gallery of Ontario
Extension Department, *Canadian Paintings of the
1930s*, October 25, 1967 – March 30, 1968, No.12.

The oil sketch is in this exhibition, No.18.

19

Pre-Cambrian Hills 1939

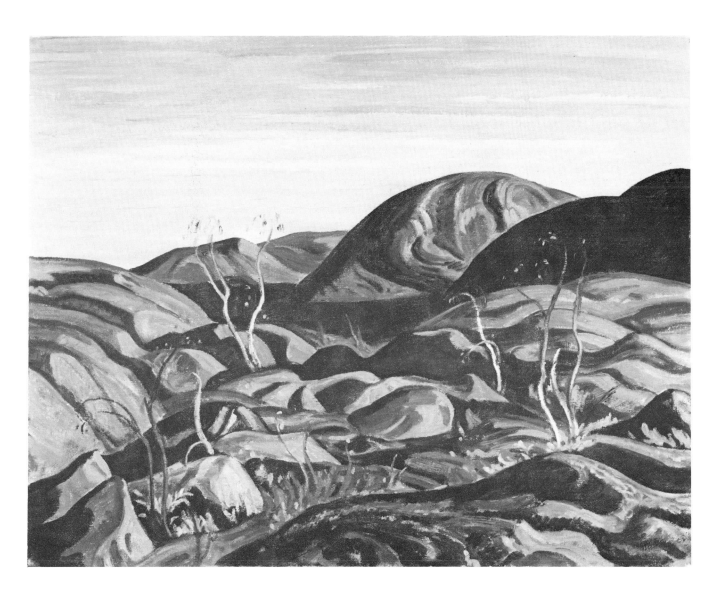

20

Radium Mine, Great Bear Lake
September 1938

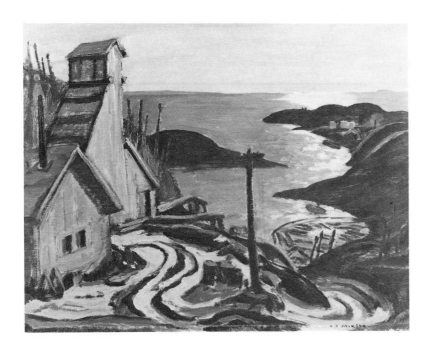

Oil on panel, 26.5 x 34.2 cm

Signed lower right: A Y JACKSON

NJG 2366

The National Gallery of Canada, Ottawa,
purchased 1939 (4542)

PROVENANCE
Acquired from the artist.

LITERATURE
NGC Canadian School, p.140.

EXHIBITION
Jackson 1953, No.220.

The work is titled and dated verso. The canvas is in
this exhibition, No.21.

Oil on canvas, 82.0 x 102.7 cm

Signed lower left: A Y JACKSON

NJG 2367

The McMichael Canadian Collection, Kleinburg,
Ontario, gift of Col. R.S. McLaughlin, Oshawa,
Ontario, 1968

PROVENANCE
Acquired from the artist.

LITERATURE
McMichael 1970, repr. Subsequent McMichael
Collection catalogues to *McMichael 1979*, p.184,
repr.

EXHIBITIONS
New York, World's Fair, *Exhibition of Canadian Art:
the Canadian Group of Painters*, August 1–
September 15, 1939, No.30. *CNE*, August 27 –
September 11, 1948, No.26.

The oil sketch is in this exhibition, No.20.

21

Radium Mine 1938

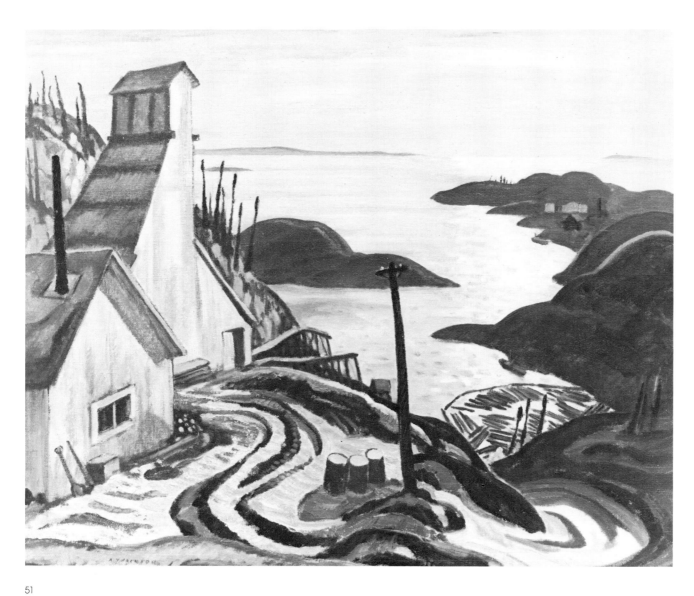

22

Looking South from Great Bear Lake 1938

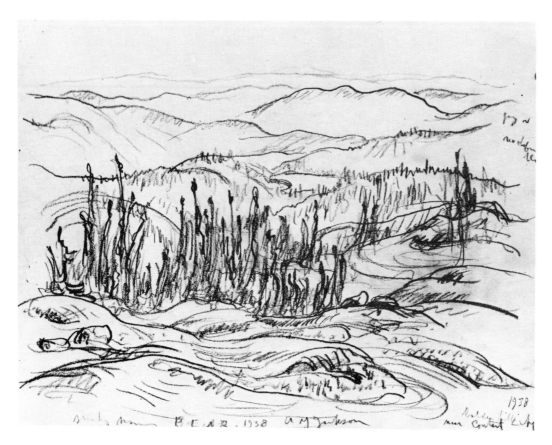

Graphite on paper, 21.6 x 28.8 cm

Signed lower right of centre: *A Y Jackson*;
inscribed and dated lower right: *1938/Barren
hills/near Contact Lake*; inscribed and dated lower
left of centre: *probably·[] BEAR 1938*

NJG 721r

Mr. and Mrs. Robert McMichael, Kleinburg, Ontario

PROVENANCE
Acquired from the artist c.1969.

LITERATURE
A.Y.'s Canada, pp.208, 242, repr. pl.97, p.209.
McMichael 1970, repr. Subsequent McMichael
Collection catalogues to *McMichael 1979*, p.186,
repr., as "South from Great Bear Lake."

The canvas is in this exhibition, No.23.

23

South from Great Bear Lake c.1939

(SEE COLOUR PLATE NO. 2)

Oil on canvas, 81.3 x 101.6 cm

NJG 2368

Art Gallery of Ontario, Toronto,
gift from the J.S. McLean Collection, on loan from the
Ontario Heritage Foundation, 1970 (L69.21)

PROVENANCE
Acquired from the artist 1939.

LITERATURE
A.Y. Jackson and Leslie F. Hannon, "From rebel
dauber to renowned painter: A self-portrait of A.Y.
Jackson," *Mayfair* XXVIII (September 1954): repr. p.29.
A.Y.'s Canada, pp.208, 242.

EXHIBITIONS
Toronto, Art Gallery of Toronto, *CGP*, October 20 –
November 13, 1939, no No. Ottawa, The National
Gallery of Canada, *Paintings and Drawings from the
Collection of J.S. McLean*, 1952, No.32. *Jackson 1953*,
No.65, repr. pl.15. Toronto, Art Gallery of Ontario, *The
J.S. McLean Collection of Canadian Painting*,
September 19 – October 20, 1968, and national tour
until 26 October 1969, No.38.

The drawing is in this exhibition, No.22.

24

Tom Thomson's Shack Behind the
Studio Building, Toronto c. 1938

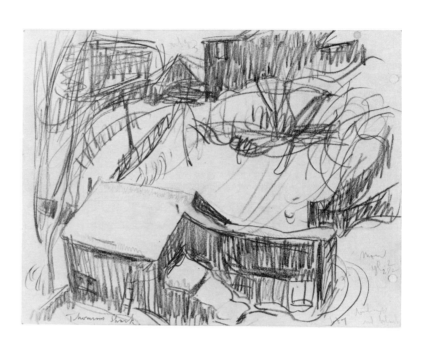

Graphite on paper, 22.7 x 30.3 cm

Inscribed lower left: *Thomsons Shack*;
in various locations with colour notations

NJG 323

Art Gallery of Ontario, Toronto,
gift of Dr. Naomi Jackson Groves, Ottawa, 1980
(80/4)

PROVENANCE
Gift of the artist c.1965.

LITERATURE
A.Y.'s Canada, pp.102, 107, 236, repr. pl.49, p.103.

25

Quebec Village in Winter c. 1938

Oil on canvas, 53.5 x 63.5 cm

NJG 2369

Private collection

PROVENANCE
Acquired from the artist by Vincent Massey of Port Hope, Ontario, 1938. By descent to Hart Massey, Ottawa, 1967. Sotheby & Co. (Canada) Ltd., Toronto, October 27, 1969, lot 92, repr. p.44, and colour cover. Purchased by the Framing Gallery, Toronto.

LITERATURE
Times Weekly Edition (London), July 7, 1938, repr.

There are two related drawings in the same collection.

Road to St. Simon c. 1940

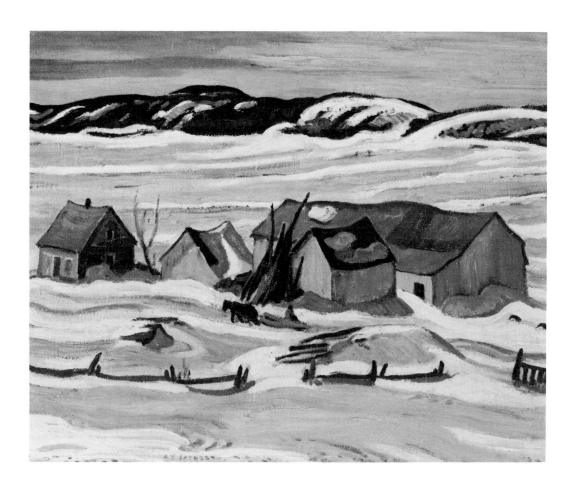

Oil on canvas, 54.0 x 66.1 cm

Signed lower left of centre: A Y JACKSON

NJG 2227

Private collection

PROVENANCE
Acquired from the artist late 1940. By descent to the present owners.

LITERATURE
A Painter's Country, repr. in colour opp. p.34, and colour dust jacket, as 1946. *A.Y.'s Canada*, pp.40, 46.

EXHIBITIONS
Toronto: Art Gallery of Toronto, 61st *RCA*, October 11 – November 11, 1940, No.87. *Jackson 1953*, No.68. Victoria, Arts Centre of Greater Victoria, *The Group of Seven*, February 15 – 27, 1955, No.9.

Algoma Lake 1940

Oil on canvas, 62.5 x 80.0 cm

Signed lower left corner: A Y JACKSON

NJG 2370

Kaspar Gallery, Toronto

PROVENANCE
Acquired from the artist by H.O. McCurry, Ottawa, 1940. Mrs. H.O. McCurry, Kingsmere, Quebec, 1964. Sotheby Parke Bernet (Canada) Inc., November 11, 1980, lot 42, repr. in colour p.21. Purchased by the Kaspar Gallery.

LITERATURE
Patrick Morgan, "Wet Paint from Canada," *Art News* XLI (October 1, 1942): repr. p.9. Walter Abell, "Neighbors to the North," *Magazine of Art* XXXV (October 1942): repr. p.210. John Alford, "The Development of Painting in Canada," *Canadian Art* II (February – March 1945): repr. colour cover. Donald W. Buchanan, *Canadian Painters: From Paul Kane to the Group of Seven* (Oxford: Phaidon Press, 1945), repr. in colour pl.IV, p.19. Donald W. Buchanan, "A.Y. Jackson – The Development of Nationalism in Canadian Painting," *Canadian Geographical Journal* XXXII (June 1946): repr. in colour p.285. A.Y. Jackson, "The Development of Canadian Art," *Journal of The Royal Society of Arts* XCVII (January 14, 1949): repr. p.134.

EXHIBITIONS
Andover, Addison Gallery of American Art, *Aspects of Contemporary Painting in Canada*, September 18 – November 8, 1942, No.35, p.48, repr. p.8. San Francisco, San Francisco Museum of Art, *Art of Our Neighbors*, June – July 1943, No.2773. New Haven, Yale University Art Gallery, *Canadian Art 1760 –1943*, March 11 – April 16, 1944, no No. Toronto, The Art Gallery of Toronto, *The Development of Painting in Canada*, January 1945; Montreal, The Art Association of Montreal, February; Ottawa, The National Gallery of Canada, March; Quebec, Le Musée de la Province de Québec, April 1945, No.151. Richmond, Virginia Museum of Fine Arts, *Exhibition of Canadian Painting 1668 –1948*, 1949, No.37.

28

North Country Algoma 1941

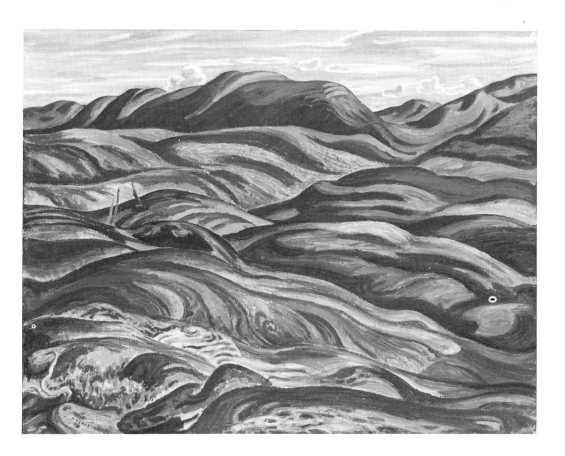

Boston, Museum of Fine Arts, *Forty Years of Canadian Painting, from Tom Thomson and the Group of Seven to the present day*, July 14 – September 25, 1949, No.41. Washington, National Gallery of Art, *Canadian Painting*, 1950, No.41; included in a reduced version of the exhibition at San Francisco, California Palace of the Legion of Honor, January 5 – 30, 1951; San Diego Museum, February 1951; Santa Barbara Museum of Art, March 1951; Seattle Art Museum, April 4 – May 6, 1951; Vancouver Art Gallery, May 15 – June 11, 1951. Ottawa, The National Gallery of Canada, *Exhibition of Canadian Painting to Celebrate the Coronation of Her Majesty Queen Elizabeth II*, 1953, No.30. *Jackson 1953*, No.69. Toronto, Kaspar Gallery, *Canadian Masters*, March 10 – 28, 1981, no No., repr. in colour.

Oil on canvas, 96.6 x 127.1 cm

Signed lower left: A Y JACKSON

NJG 2371

Bram Garber, Montreal

PROVENANCE
Walter Klinkhoff Gallery, Montreal.

LITERATURE
A Collector's Choice of Canadian Art: The Bram Garber Collection (Montreal: Peerless Rug Limited, 1981), repr. in colour p.13.

EXHIBITION
CNE, 1941, no No., as "Autumn, Algoma."

29

Camp Mile 108, West of Whitehorse
October 1943

Oil on panel, 26.7 x 34.2 cm

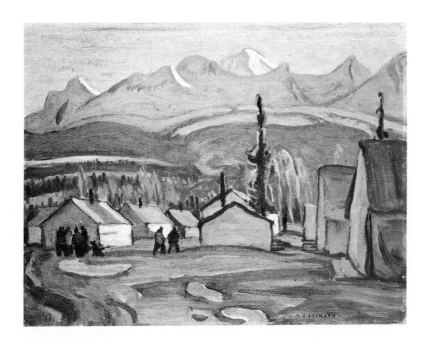

Signed lower right: A Y JACKSON.

NJG 2372

The National Gallery of Canada, Ottawa,
purchased 1945 (4616)

PROVENANCE
Acquired from the artist.

LITERATURE
NGC Canadian School, p.141.

EXHIBITION
Toronto, Eaton's Fine Art Galleries, *Wartime Paintings
of the West Coast and the Alaska Highway*, May 17 –
27, 1944, no No.

The work is titled and dated verso.

30

*Alaska Highway Between Watson Lake
and Nelson* October 1943

Oil on panel, 26.5 x 34.1 cm

31

Highway South of Nelson October 1943

Oil on panel, 26.8 x 34.3 cm

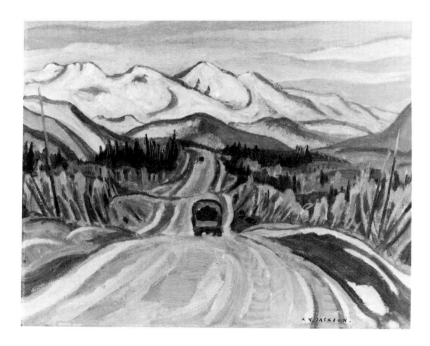

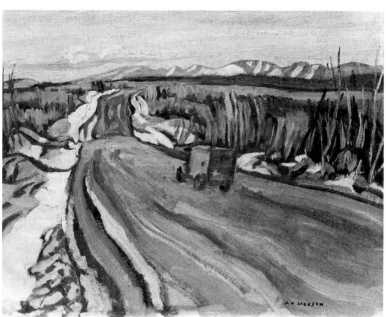

NJG 2373

The National Gallery of Canada, Ottawa,
purchased 1945 (4617)

PROVENANCE
Acquired from the artist.

LITERATURE
A.Y. Jackson, "Sketching on the Alaska Highway,"
Canadian Art I (February – March 1944): repr. p.89.
NGC Canadian School, p.141, repr.

EXHIBITIONS
Toronto, Eaton's Fine Art Galleries, *Wartime Paintings
of the West Coast and the Alaska Highway*, May 17 –
27, 1944, no No. *Jackson 1953*, No.224.

The work is titled and dated verso.

Signed lower right: A Y JACKSON.

NJG 2397

The National Gallery of Canada, Ottawa,
purchased 1945 (4620)

PROVENANCE
Acquired from the artist.

LITERATURE
NGC Canadian School, p.141.

EXHIBITION
Toronto, Eaton's Fine Art Galleries, *Wartime Paintings
of the West Coast and the Alaska Highway*, May 17 –
27, 1944, no No.

The work is titled and dated verso.

32

Mountains on the Alaska Highway c. 1943

Oil on canvas, 81.4 x 101.6 cm

Signed lower right: A Y JACKSON

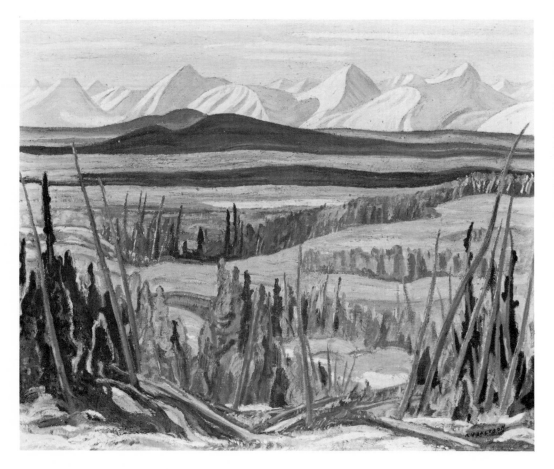

NJG 2374

Mr. and Mrs. N.D. Young, Toronto

PROVENANCE
Acquired from the artist, c.1950.

EXHIBITION
Jackson 1953, No.71. *Jackson 1960*, No.84, as

"Mountains in the Yukon."

Inscribed on the stretcher: Mountains on the HAINES
ROAD ALASKA. Also verso is a label attached to
the centre of the canvas inscribed: MOUNTAINS IN
THE/YUKON/A.Y. JACKSON.

33

Wild Woods c. 1945

(SEE COLOUR PLATE NO. 3)

Oil on canvas, 53.7 x 66.4 cm

Signed lower left: A Y JACKSON

NJG 851

Vancouver Art Gallery, purchased 1949 (49.16)

PROVENANCE
Acquired from the artist.

EXHIBITIONS
73rd *OSA*, March 3 – April 1, 1945, No.83. 63rd *AAM*,
March 28 – April 28, 1946, No.136. *Jackson 1953*,
No.73.

34

West from Pincher Creek 1947

Oil on panel, 26.7 x 34.3 cm
Signed lower right: A Y JACKSON

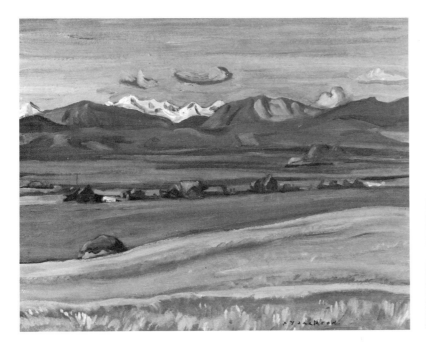

35

Rain Squall, Canmore September 1947

Oil on panel, 26.5 x 34.3 cm
Signed lower right: A Y JACKSON

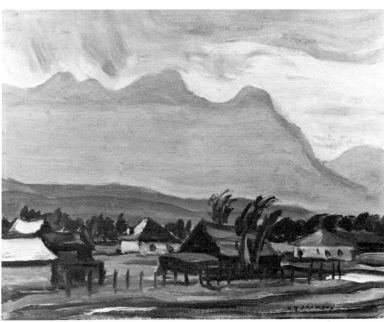

NJG 832

Glenbow Museum, Calgary, Alberta, purchased 1955 (55.30.2)

PROVENANCE
Dominion Gallery, Montreal.

EXHIBITIONS
Montreal, Dominion Gallery, *Exhibition of Paintings
and Sketches by A.Y. Jackson*, April 24 – May 8, 1948,
No.52. Edmonton, The Edmonton Art Gallery, *The
Group of Seven in the Rockies*, April 17 – May 19,
1974; The Dunlop Art Gallery, Regina, May 31 – June
23, 1974; The Peter Whyte Gallery, Banff, July 1 – 21,
1974, no No., repr. Edmonton, The Edmonton Art
Gallery, *Painting in Alberta, An Historical Survey*, July
11 – August 31, 1980, No.56. Lethbridge, The Southern
Alberta Art Gallery, *A.Y. Jackson in Southern Alberta*,
December 5, 1981 – January 3, 1982, No.19.

NJG 2375

Private collection

PROVENANCE
Christie's, Montreal, November 15, 1972, lot 54, repr.
p.33.

EXHIBITIONS
Edmonton, The Edmonton Art Gallery, *Art in Alberta:
Paul Kane to the Present*, April 6 – May 10, 1973; The
Glenbow-Alberta Institute, Calgary, July 1 – August
25, 1973, no No., repr. Edmonton, The Edmonton Art
Gallery, *Painting in Alberta, An Historical Survey*, July
11 – August 31, 1980, No.60, repr. in colour.

Elevators at Night, Pincher Creek, Alberta
1947

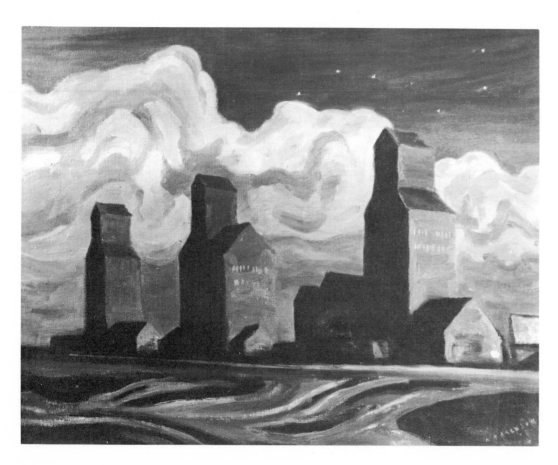

Oil on canvas, 50.8 x 66.0 cm

Signed lower right: A Y JACKSON

NJG 2310

Lethbridge Community College, Lethbridge, Alberta, gift of Donald and Hugh Buchanan, 1966

PROVENANCE
Acquired from the artist by members of the Canadian Press Association as a gift for Hon. W.A. Buchanan, Lethbridge, 1948. By descent to Donald and Hugh Buchanan.

LITERATURE
Barker Fairley, "What is Wrong with Canadian Art?" *Canadian Art* VI (Autumn 1948): repr. p.26. Donald W. Buchanan, "Canadian Painting 1947–1948," *Studio* CXXXVII (January 1949): repr. p.13. *A.Y.'s Canada*, p.132.

EXHIBITIONS
Ottawa, The National Gallery of Canada, *Exhibition of Canadian Painting to Celebrate the Coronation of Her Majesty Queen Elizabeth* II, 1953, No.29, as "painted 1947." *Jackson 1953*, No.75, as c.1949. Mexico City, Museo Nacional de Arte Moderno, *Arte Canadiense*, November 1960, No.124, as 1950. Ottawa, The National Gallery of Canada, *Three Hundred Years of Canadian Art*, 1967, No.271, repr. p.161. Lethbridge, Southern Alberta Art Gallery, *Southern Alberta Collects*, March 6–April 4, 1976, No.15, repr. Edmonton, The Edmonton Art Gallery, *Painting in Alberta, An Historical Survey*, July 11–August 31, 1980, No.53. Lethbridge, Southern Alberta Art Gallery, *A.Y. Jackson in Southern Alberta*, December 5, 1981–January 3, 1982, No.26, repr. colour cover.

37

Chinook, Cowley, Alberta c. 1948

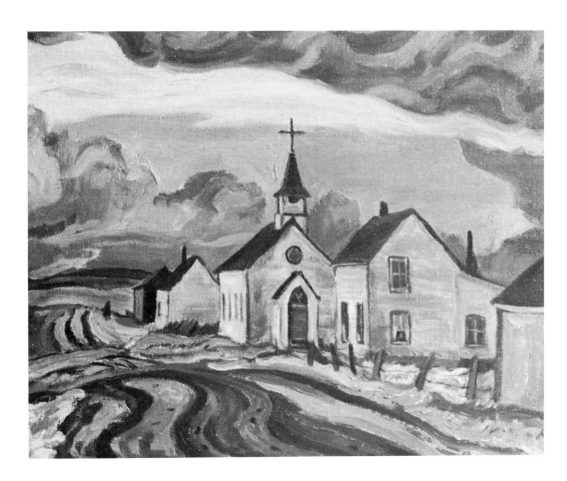

Oil on canvas, 52.4 x 60.9 cm

Signed lower right of centre: A Y JACKSON

NJG 2376

Kenneth G. Heffel Fine Art Inc., Vancouver

PROVENANCE
Christie, Manson & Woods (Canada), Montreal, October 19, 1973, lot 63, repr. colour p.29, as "Alberta Village." Purchased by the Art Emporium, Vancouver. George Clarke, Vancouver (the Fannin Hall Collection). Kenneth G. Heffel Fine Art Inc., 1979. Paul Vanier, Montreal. Acquired by the present owner, 1981.

EXHIBITION
Montreal, Art Association of Montreal, *CGP*, 1949, No.27, as "Alberta Village."

The drawing, entitled *Cowley*, NJG 1445r, dated October 12, 1947, is in the collection of the University of Lethbridge.

38

Alberta Rhythm 1948

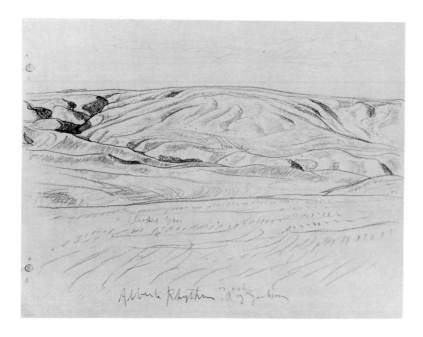

Graphite on paper, 22.8 x 30.5 cm

Signed lower right of centre: *A Y Jackson*;
inscribed lower left of centre: *Alberta Rhythm*;
inscribed throughout with colour notations

NJG 144

Art Gallery of Ontario, Toronto,
gift of Dr. Naomi Jackson Groves, Ottawa, 1981
(81/540)

PROVENANCE
Gift of the artist c.1969.

LITERATURE
A.Y.'s Canada, pp.134, 238, repr. pl.63, p.135.

The canvas is in this exhibition, No.39.

39

Alberta Rhythm 1948

(SEE COVER)

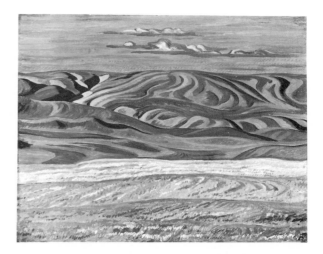

Oil on canvas, 97.8 x 127.0 cm

Signed lower right of centre: A Y JACKSON

NJG 2377

Private collection

PROVENANCE
Gift of Wilhemina and Lillian Elliot, c.1955.

LITERATURE
A.Y.'s Canada, p.134.

EXHIBITIONS
Toronto, Art Gallery of Toronto, 77th *OSA*, March 5–
27, 1949, No.49. Montreal, Montreal Museum of Fine
Arts, 70th *RCA*, November 11–30, 1949, No.49.
Jackson 1953, No.77.

The date, 1948, and the dimensions, 38 x 50 in., were
added to the copy of the OSA catalogue now in the
Reference Library of the Art Gallery of Ontario as
part of a general notation made at the time of the
exhibition in 1949. The catalogue of the 1953
exhibition gives the date as c.1949. The drawing is in
this exhibition, No.38.

40

The Great Lone Land, Eldorado
September 1949

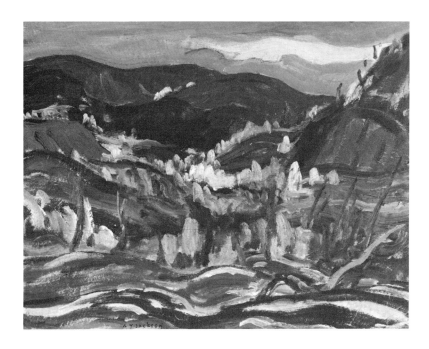

Oil on panel, 26.8 x 34.5 cm

Signed lower left: A Y JACKSON

NJG 2378

The Edmonton Art Gallery, gift of the
Ernest E. Poole Foundation, 1968 (68.6.44)

EXHIBITIONS
Victoria, The Art Gallery of Greater Victoria,
*Paintings from the Collection of Ernest E. Poole and
Family*, August 4 – September 13, 1959, also at
Vancouver, Fine Arts Gallery, University of British
Columbia, November 1 – 18, 1959, No.37. Edmonton,
The Northern Alberta Jubilee Auditorium (The
Edmonton Art Gallery), *The Ernest E. Poole
Foundation Collection, An Exhibition of Canadian
Painting*, April 24 – 29, May 2 – 6, 1966, No.25.
Edmonton, The Edmonton Art Gallery, *The Ernest E.
Poole Foundation Collection*, November 8 –
December 8, 1974, No.62, repr.

The work is dated and titled verso. There is a canvas,
exhibited *CGP*, Art Gallery of Toronto, 1950, Montreal
Museum of Fine Arts, 1951, No.47, repr. *Montreal Star*,
January 13, 1951. Present location unknown.

41

Muskeg Pool 1949

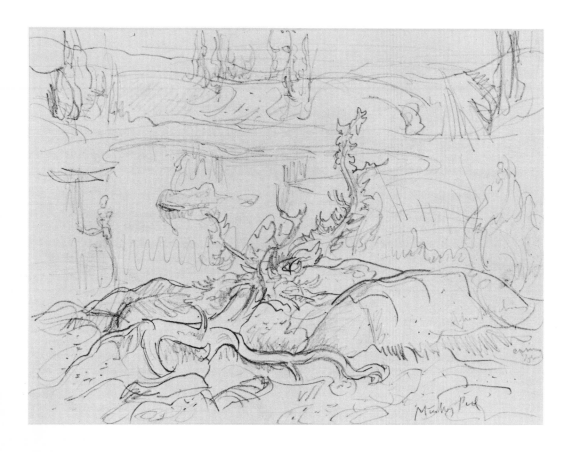

Oil on canvas, 40.6 x 50.8 cm

Signed lower right of centre: A Y JACKSON

NJG 1631

Private collection

PROVENANCE
Acquired from the artist by Sydney Hamilton. Roberts Gallery, Toronto. Sotheby & Co. (Canada) Ltd., Toronto, October 21, 1974, lot 79, repr. p.39.

The drawing is in this exhibition, No.41.

Graphite on paper, 21.8 x 29.8 cm

Inscribed lower right: *Muskeg Pool*

NJG 729r

Private collection

PROVENANCE
Acquired from the estate of the artist 1980.

The canvas is in this exhibition, No.42.

42

Muskeg, Port Radium, Northwest Territories
c. 1949

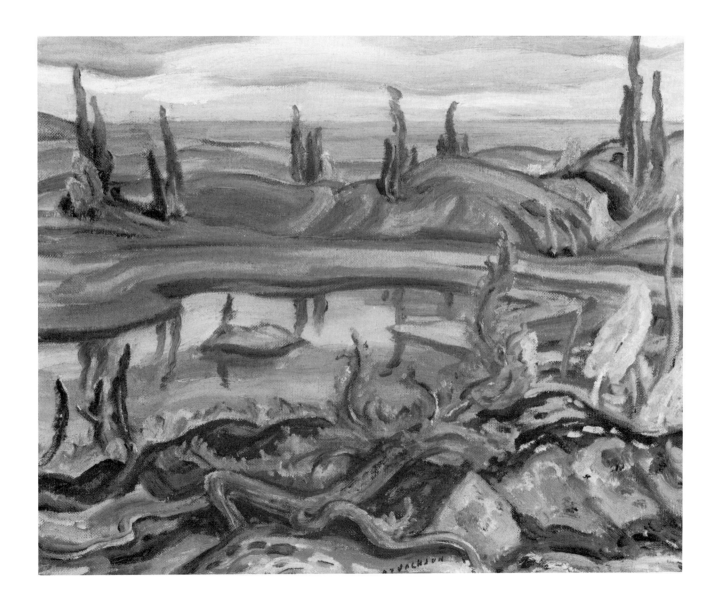

43

Evening, Teshierpi August 1950

Oil on panel, 26.2 x 34.2 cm

Signed lower left of centre: A Y JACKSON.

NJG 2380

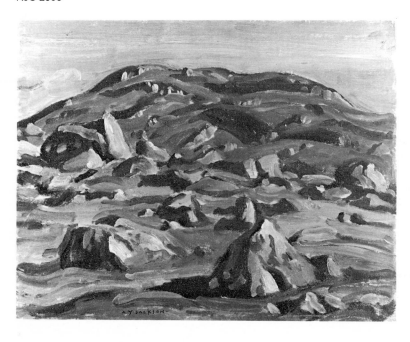

The National Gallery of Canada, Ottawa,
purchased 1954 (6262)

PROVENANCE
Acquired from the artist.

LITERATURE
NGC Canadian School, p.143.

EXHIBITION
Montreal, Montreal Museum of Fine Arts [*Arthur
Lismer and A.Y. Jackson*], November 15–26, 1952,
No.18.

The work is titled and dated verso.

44

Looking South from Teshierpi Mountains August 1950

Oil on panel, 26.5 x 34.4 cm

Signed lower right: A Y JACKSON

NJG 2379

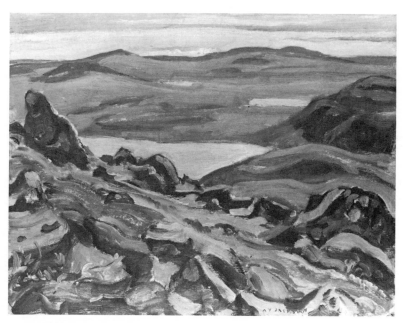

The National Gallery of Canada, Ottawa,
purchased 1954 (6261)

PROVENANCE
Acquired from the artist.

LITERATURE
NGC Canadian School, p.143, repr.

EXHIBITION
Montreal, Montreal Museum of Fine Arts [*Arthur
Lismer and A.Y. Jackson*], November 15–26, 1952,
No.20.

The work is titled and dated verso. A related drawing
is in this exhibition, No.45. A canvas was presented to
Dr. A.L. Washburn, Wilmette, Illinois, President of the
Arctic Institute of North America, 1952, repr. in
"Institute News," *Arctic* v (July 1952):128.

45

Looking South from Teshierpi Mountain
in the Barren Lands 25 August 1950

Graphite and red pencil on paper, 22.75 x 30.4 cm

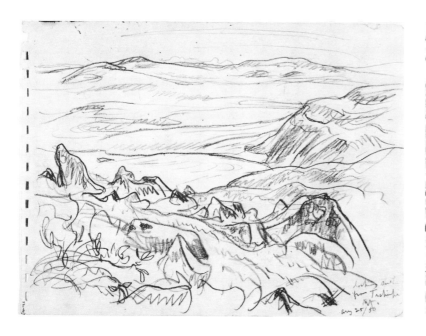

46

Teshierpi Mountains, Barren Lands
August 1950

Oil on panel, 26.5 x 34.2 cm

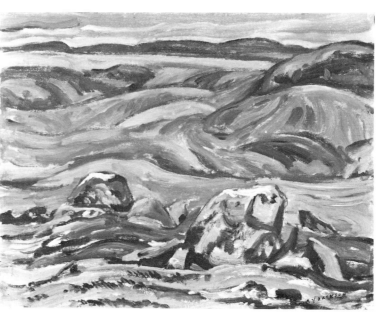

Inscribed lower right: *looking south/from*
Teshierpi/Mt./Aug 25/50

NJG 730r

The National Gallery of Canada, Ottawa,
gift of the artist, Kleinburg, 1969 (15786.10)

LITERATURE
A.Y.'s Canada, pl.104, p.224.

There is a related sketch in this exhibition, No.44. See
note in that entry concerning a canvas.

Signed lower right: A Y JACKSON

NJG 2381

Mr. and Mrs. N.D. Young, Toronto

PROVENANCE
Acquired from the artist c.1955.

The work is signed, titled, and dated verso. Also
inscribed centre verso: *Reserved Eldorado*.

47

Lakes and Muskeg, Hunter Bay,
Great Bear Lake August 1951

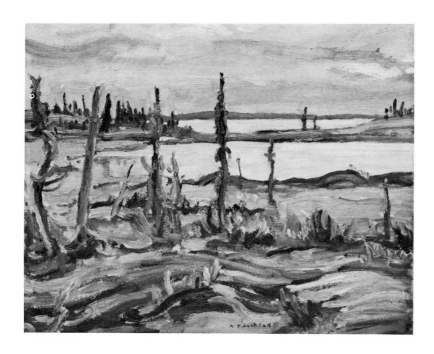

Oil on canvas, 61.0 x 81.3 cm

Signed lower left of centre: A Y JACKSON

NJG 2382

Sally Stewart Douglas, Toronto

PROVENANCE
Acquired from the artist by Walter Stewart, Toronto
before 1955. By descent to the present owner.
Waddington's, Toronto, May 7, 1981, lot 854, repr.
p.18, bought in.

EXHIBITION
Toronto, Art Gallery of Toronto, 76th *RCA*, November
25, 1955 – January 2, 1956, No.49, repr.

The work is titled and dated verso.

Oil on panel, 26.4 x 34.1 cm

Signed lower right of centre: A Y JACKSON

NJG 2231

Art Gallery of Greater Victoria,
Gift of Mrs. H.A. Dyde, 1979 (79.16)

PROVENANCE
Acquired from the artist 1951.

EXHIBITION
Victoria, Arts Centre of Greater Victoria, *The Group
of Seven*, February 15 – 27, 1955, No.14.

The work is titled and dated verso.

48

Hills at Hunter Bay, Great Bear Lake
1951

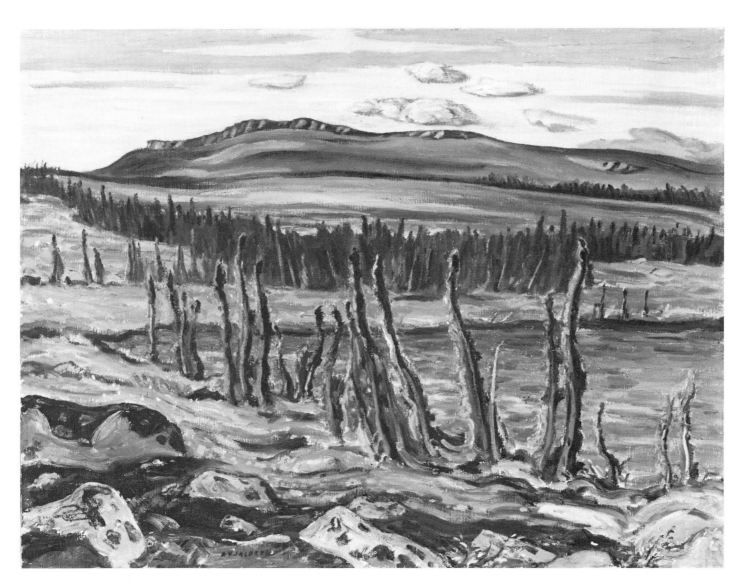

49

October, Twin Butte, Alberta 1951

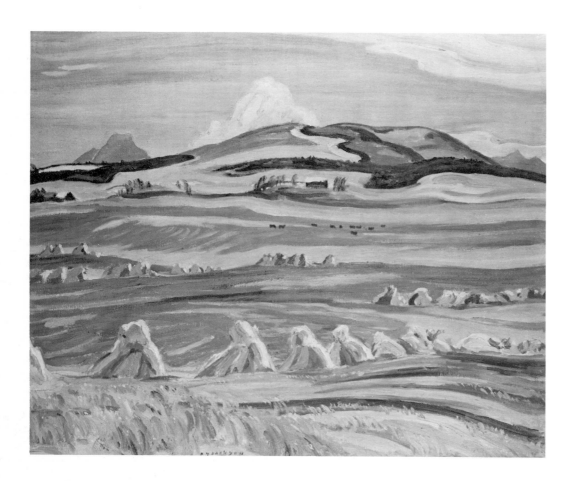

Oil on canvas, 64.2 x 81.5 cm

Signed lower left of centre: A Y JACKSON

NJG 2383

The National Gallery of Canada, Ottawa, purchased 1956 (6456)

PROVENANCE
Acquired from the artist.

LITERATURE
A Painter's Country, repr. in colour opp. p.66. *NGC Canadian School*, p.144, repr.

EXHIBITION
79th *OSA*, March 10 – April 15, 1951, No.42, repr.

50

Winter Road, Ste. Cecile de Masham 1952

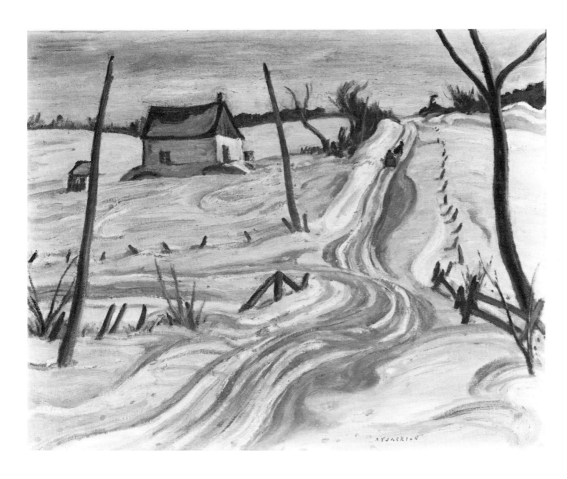

Oil on canvas, 64.1 x 81.3 cm

Signed lower right: A Y JACKSON

NJG 1525

Private collection

<small>PROVENANCE</small>
Acquired from the artist c.1955.

<small>EXHIBITION</small>
Jackson 1960, No.5.

51

April Day, Ste. Marthe, Gaspé 1953

(SEE COLOUR PLATE NO. 4)

52

Country Road, Alberta c. 1954

(SEE COLOUR PLATE NO. 5)

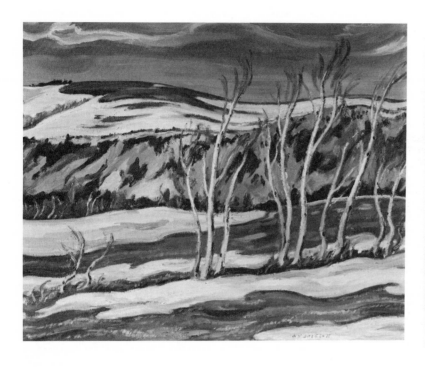

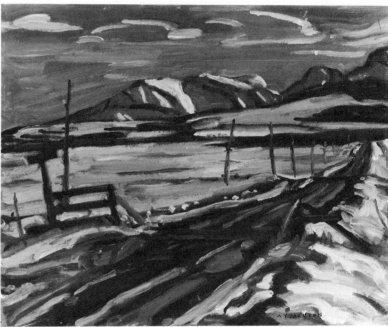

Oil on canvas, 51.5 x 64.1 cm

Signed lower right: A Y JACKSON

NJG 58

Private collection

PROVENANCE
Gift of the artist c.1953.

There is an oil sketch in a private collection, dated
verso *April 1953*.

Oil on panel, 26.7 x 33.4 cm

Signed lower right: A Y JACKSON

NJG 50

Art Gallery of Ontario, Toronto,
gift of Dr. Naomi Jackson Groves, Ottawa, 1981
(81/539)

PROVENANCE
Gift of the artist c.1955.

53

Elevators at Pincher Creek April 1954

54

The Bar X Ranch, Pincher Creek, Alberta
May 1954

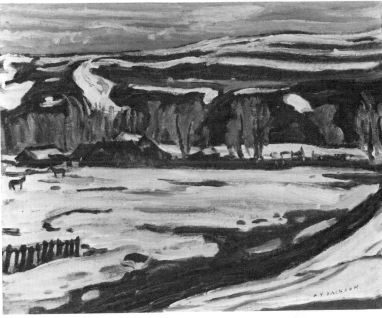

Oil on panel, 26.6 x 34.3 cm

Signed lower right: A Y JACKSON.

NJG 1528

Private collection

PROVENANCE
Acquired from the artist c.1955.

There is a winter landscape of the southern Alberta foothills verso.

Oil on panel, 27.0 x 34.2 cm

Signed lower right: A Y JACKSON

NJG 1474

Private collection

PROVENANCE
Acquired from the artist 1954. By descent to the present owners.

EXHIBITION
Lethbridge, Southern Alberta Art Gallery, *A.Y. Jackson in Southern Alberta*, December 5, 1981 – January 3, 1982, hors cat.

The work is titled and dated verso.

55

Monument Channel, Georgian Bay
July 1953

56

Pickerel Weed, Georgian Bay July 1954

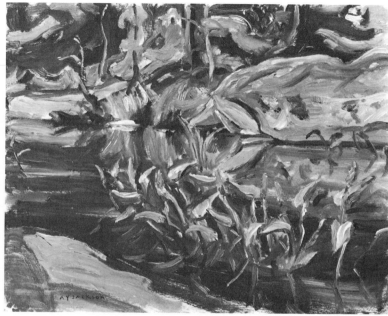

Oil on panel, 26.5 x 34.3 cm

Signed lower right: A Y JACKSON

NJG 2384

Art Gallery of Ontario, Toronto,
gift of the artist, 1953 (53/8)

LITERATURE
AGO Canadian Collection, p.213. Peter Mellen, *The Group of Seven* (Toronto/Montreal: McClelland and Stewart Limited, 1970), repr. pl.224, p.193.

EXHIBITION
Jackson 1953, No.234.

The work is titled and dated verso. There is also an unfinished oil sketch verso.

Oil on panel, 26.5 x 34.1 cm

Signed lower left: A Y JACKSON

NJG 2385

Mr. and Mrs. N.D. Young, Toronto

PROVENANCE
Acquired from the artist c.1955.

The work is signed, titled, and dated verso.

Georgian Bay Islands 1955

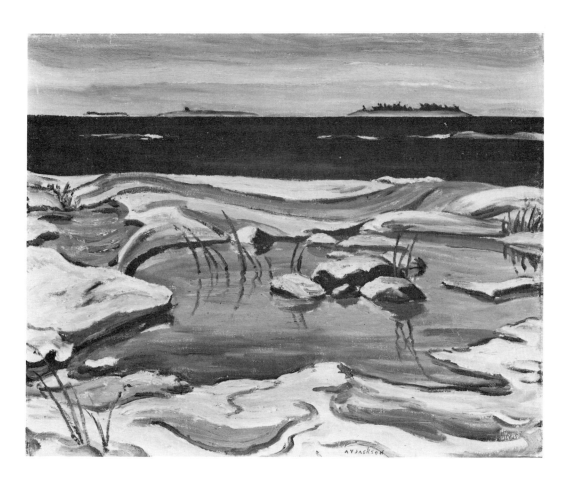

Oil on canvas, 50.6 x 64.0 cm

Signed lower right of centre: A Y JACKSON

NJG 2386

Mr. and Mrs. N.D. Young, Toronto

PROVENANCE
Acquired from the artist c.1958.

LITERATURE
A Painter's Country, repr. in colour opp. p.114, as
"Islands, Georgian Bay, 1954."

EXHIBITION
Jackson 1960, No.88.

The work is signed, titled, and dated verso.

58

Shoreline at Wawa, Lake Superior
August 1954

59

Stream Bed, Lake Superior Country 1955

Oil on panel, 26.6 x 34.2 cm

Signed lower right: A Y JACKSON

NJG 1531

Private collection

PROVENANCE
Acquired from the artist c.1955.

The work is signed, titled, and dated verso.

Oil on panel, 26.7 x 34.3 cm

NJG 2387

The National Gallery of Canada, Ottawa,
purchased 1955 (6400)

PROVENANCE
Acquired from the artist.

LITERATURE
NGC Canadian School, p.144.

Inscribed verso: *Walter Stewart / canvas 16 x 20?*

60

MacIntosh Bay, Lake Athabasca, Saskatchewan
September 1957

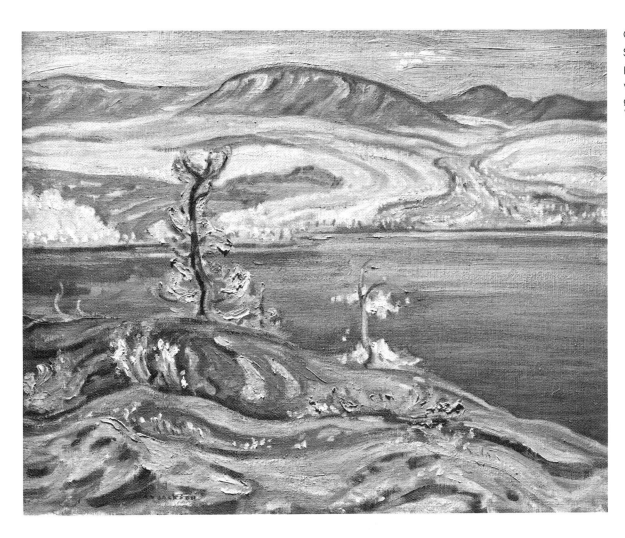

Oil on canvas, 51.2 x 63.7 cm

Signed lower left of centre: A Y JACKSON

NJG 2388

Vancouver Art Gallery,
gift of the Vancouver Art Gallery
Women's Auxiliary, 1968 (68.21)

61

Near Atnick Lake, Northwest Territories 1959

(SEE COLOUR PLATE NO. 6)

62

Country North of Atnick Camp, Barren Lands
August 1959

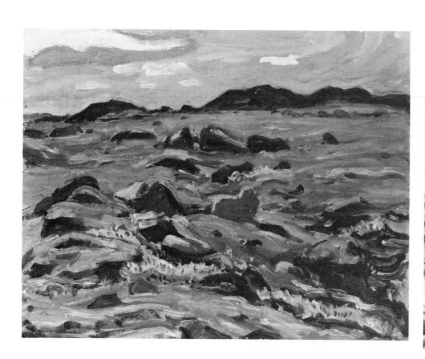

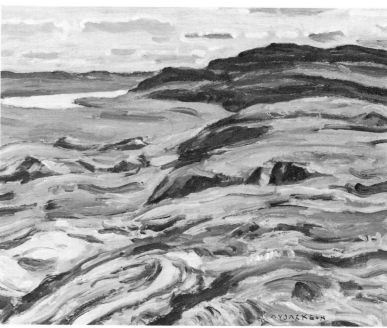

Oil on panel, 26.7 x 34.3 cm

NJG 257

Private collection

PROVENANCE
Gift of the artist c.1960.

The work is titled verso. A canvas is in a private collection.

Oil on panel, 26.7 x 34.3 cm

Signed lower right: A Y JACKSON

NJG 256

Private collection

PROVENANCE
Acquired from the artist. By descent to the present owners.

A canvas, *Coppermine River*, is in an Ottawa private collection.

63

Atnick Lake, Barren Lands
August 1959

64

Lake Rouvière, Northwest Territories
9 September 1959

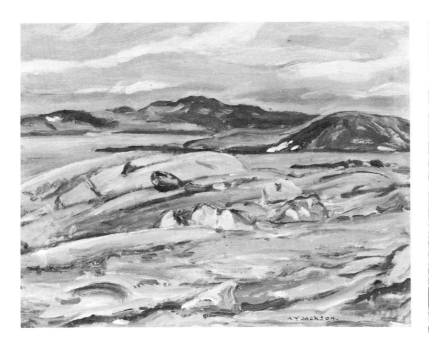

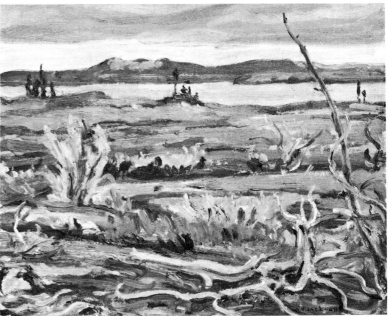

Oil on panel, 26.7 x 34.3 cm

Signed lower right: A Y JACKSON.

NJG 2230

Private collection

PROVENANCE
Acquired from the artist 1961. By descent to the
present owners.

Oil on panel, 26.7 x 34.3 cm

Signed lower right: A Y JACKSON

NJG 788

Art Gallery of Greater Victoria,
gift of the artist, 1961 (61.49)

EXHIBITION
Victoria, Art Gallery of Greater Victoria, *Nationalism
in Canadian Art*, January 31–March 30, 1979, No.27.

The work is titled and dated verso. It is the sketch for
a canvas in this exhibition, No.65.

65

Lake Rouvière 1961

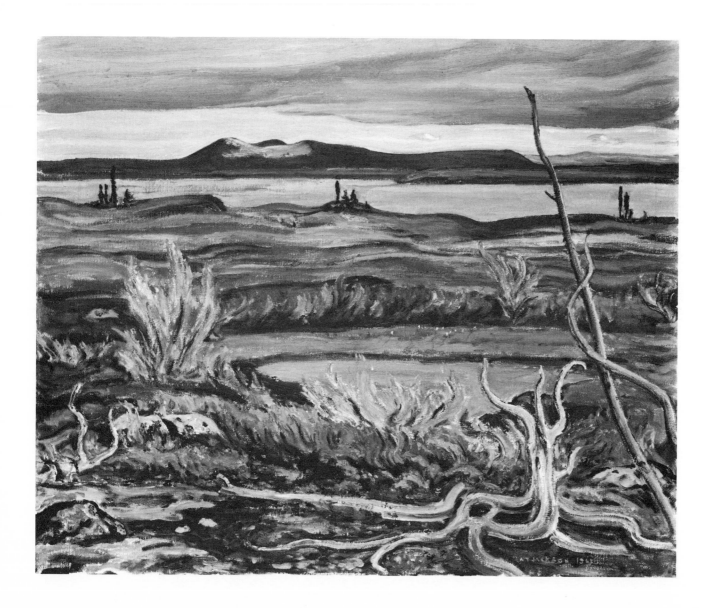

End of Winter, Labrador, Near Knob Lake
1961

Oil on canvas, 81.3 x 101.6 cm

Signed and dated lower right: A Y JACKSON 1961

NJG 2390

Ontario Heritage Foundation,
Firestone Art Collection, Ottawa

PROVENANCE
Acquired from the artist.

LITERATURE
Firestone, Jackson No.177, p.82, repr. in colour p.145.
O.J. Firestone, *The Other A.Y. Jackson, A Memoir*
(Toronto: McClelland and Stewart, 1979), pp.196-
200, repr. p.197, and in colour on the dust jacket.

The painting is dated *Sept. 1959* verso, in reference
to the date of the oil sketch. It hung in the
Washington residence of the Canadian
Ambassador to the United States between 1966 and
1970. The sketch is in this exhibition, No.64.

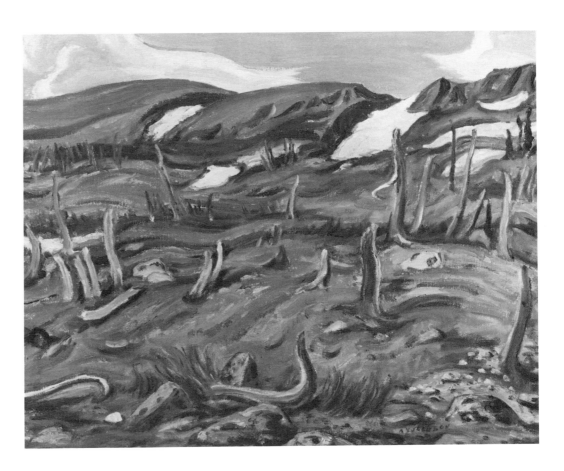

Oil on canvas, 63.5 x 81.3 cm

Signed lower right: A Y JACKSON

NJG 2389

Private collection

PROVENANCE
Walter Klinkhoff Gallery, Montreal.

67

Devil's Warehouse Island, Lake Superior
July 1962

68

Indian Church at Brantford, Ontario
April 1963

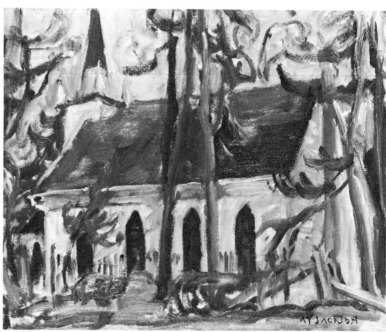

Oil on panel, 26.7 x 34.3 cm

Signed lower left: A Y JACKSON

NJG 2391

Ontario Heritage Foundation,
Firestone Art Collection, Ottawa

PROVENANCE
Acquired from the artist.

LITERATURE
Firestone, Jackson No.236, p.85.

The work is titled and dated verso.

Oil on panel, 21.6 x 26.7 cm

Signed lower right: A Y JACKSON

NJG 2392

Ontario Heritage Foundation,
Firestone Art Collection, Ottawa

PROVENANCE
Acquired from the artist.

LITERATURE
Firestone, Jackson No.193, p.83.

The work is titled and dated verso.

69

View from Morris Island, Go Home Bay
1 August 1963

70

Gatineau River 19 October 1963

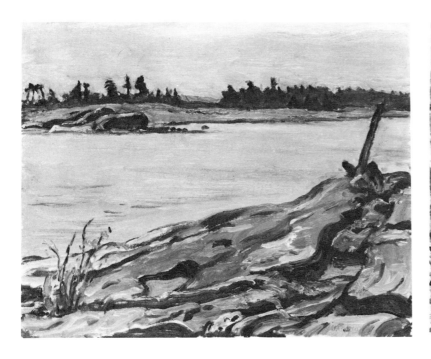

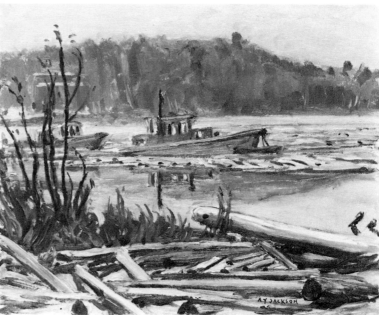

Oil on panel, 26.7 x 34.3 cm

Signed lower right: A Y JACKSON

NJG 2393

Ontario Heritage Foundation,
Firestone Art Collection, Ottawa

PROVENANCE
Acquired from the artist.

LITERATURE
Firestone, Jackson No.203, p.83.

The work is titled and dated verso.

Oil on panel, 26.7 x 34.3 cm

Signed lower right: A Y JACKSON

NJG 2394

Ontario Heritage Foundation,
Firestone Art Collection, Ottawa

PROVENANCE
Acquired from the artist.

LITERATURE
Firestone, Jackson No.195, p.83.

The work is titled and dated verso.

71

Near Wilno, Ontario March 1964

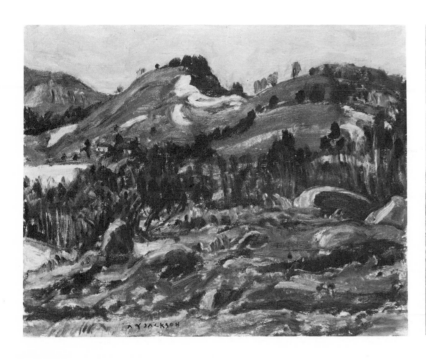

Oil on panel, 26.7 x 34.3 cm

Signed lower left of centre: A Y JACKSON

NJG 2395

Ontario Heritage Foundation,
Firestone Art Collection, Ottawa

PROVENANCE
Acquired from the artist.

LITERATURE
Firestone, Jackson No.215, p.84.

The work is titled and dated verso.

72

Windy Day, Clontarf, Ontario 4 July 1964

(SEE COLOUR PLATE NO. 7)

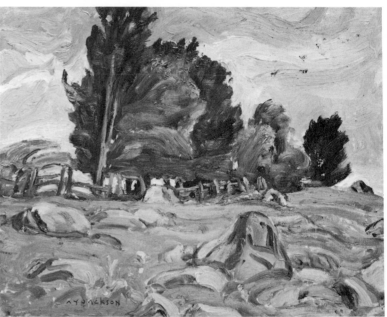

Oil on panel, 26.7 x 34.2 cm

Signed lower left: A Y JACKSON

NJG 2396

Art Gallery of Greater Victoria,
gift of the artist, 1964 (64.114)

The work is titled and dated verso.

73

Burnt Land, Haines Highway, Yukon
September 1964

74

Frobisher, Baffin Island July 1965

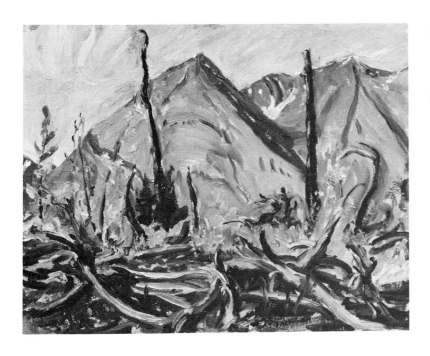

Oil on panel, 26.6 x 34.2 cm

Signed lower right: A Y JACKSON

NJG 182

Art Gallery of Greater Victoria,
gift of the artist, 1965 (65.46)

The work is titled and dated verso, and bears the
additional inscription: *Jane Parkinson*.

Oil on panel, 26.7 x 34.3 cm

Signed lower right: A Y JACKSON

NJG 880

Ontario Heritage Foundation,
Firestone Art Collection, Ottawa

PROVENANCE
Acquired from the artist.

LITERATURE
Firestone, Jackson No.229, p.85.

The work is titled and dated verso. The canvas,
Frobisher Bay Village, is repr. in colour in "A Portfolio
of Arctic Sketches," *The Beaver* Outfit 297 (Spring
1967): pl.4.

75

From Camp toward Highway Glacier, Baffin Island July 1965

Oil on panel, 26.7 x 34.3 cm
Signed lower right: A Y JACKSON

NJG 862

Private collection

PROVENANCE
Gift of the artist 1965.

LITERATURE
"A Portfolio of Arctic Sketches," *The Beaver* Outfit 297
(Spring 1967): repr. in colour pl.2. Alfred W. Purdy,
North of Summer (Toronto: McClelland and Stewart
Limited, 1967), repr. in colour p.10.

EXHIBITION
Montreal, Walter Klinkhoff Gallery, November 1965
[*Baffin Island Paintings by A.Y. Jackson*], No.20.

The work is signed, titled, and dated on a label
verso.

76

Mount Loki up Turner Glacier July 1965

Oil on panel, 26.7 x 34.3 cm
Signed lower right: A Y JACKSON

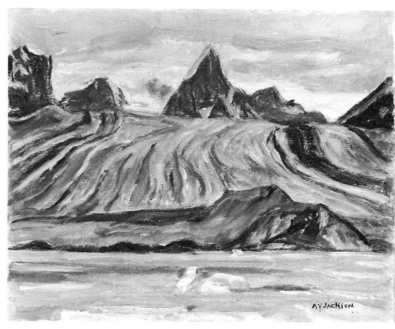

NJG 875

Private collection

PROVENANCE
Gift of the artist 1965.

LITERATURE
The Beaver Outfit 297 (Spring 1967): repr. colour
cover, as "Baffin Island/Mount Loki."

EXHIBITION
Montreal, Walter Klinkhoff Gallery, November 1965
[*Baffin Island Paintings by A.Y. Jackson*], No.22.

The work is signed, titled, and dated on a label
verso. The canvas is repr. in colour in "Portfolio of
Arctic Sketches," *The Beaver* Outfit 297 (Spring 1967):
pl.8.

77

Camp Beach Looking East July 1965

(SEE COLOUR PLATE NO. 8)

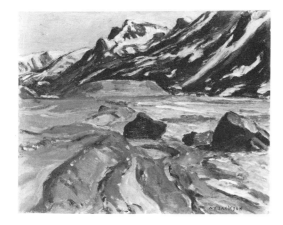

78

Mount Asgard, Baffin Island July 1965

Oil on panel, 26.7 x 34.3 cm
Signed lower right: A Y JACKSON

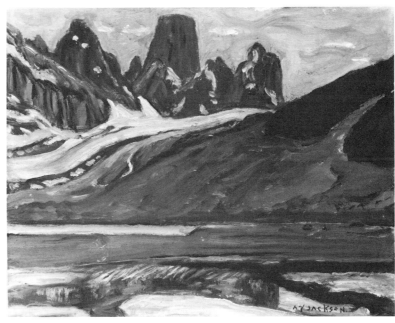

Oil on panel, 26.7 x 34.3 cm
Signed lower right: A Y JACKSON
NJG 868

Private collection

PROVENANCE
Gift of the artist 1965.

EXHIBITION
Montreal, Walter Klinkhoff Gallery, November 1965
[*Baffin Island Paintings by A.Y. Jackson*], No.10.

The work is signed, titled, and dated on a label
verso. A related work is repr. in colour in "Portfolio of
Arctic Sketches," *The Beaver* Outfit 297 (Spring 1967):
pl.5.

NJG 865

Private collection

PROVENANCE
Gift of the artist 1965.

LITERATURE
"A Portfolio of Arctic Sketches," *The Beaver* Outfit 297
(Spring 1967): repr. in colour pl.1. Alfred W. Purdy,
North of Summer (Toronto: McClelland and Stewart
Limited, 1967), repr. in colour p.9.

EXHIBITION
Montreal, Walter Klinkhoff Gallery, November 1965
[*Baffin Island Paintings by A.Y. Jackson*], No.27.

The work is inscribed verso: Mount Asgard – with
Turner Glacier in Foreground – and a bit of Glacier
Lake – Pangnirtung Pass – Baffin Island/July 1965.
Signed, titled, and dated on a label verso. A canvas
based on a related sketch is repr. in colour in *A
Painter's Country*, opp. p.115.

79

Turner Glacier, Stormy July 1965

80

View from Ireland's Island 1967

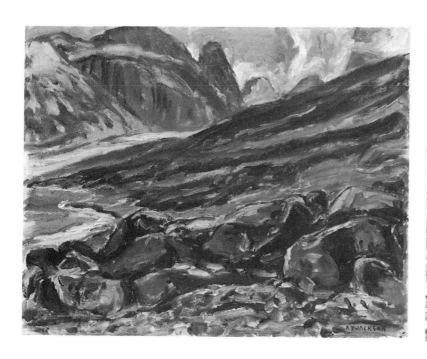

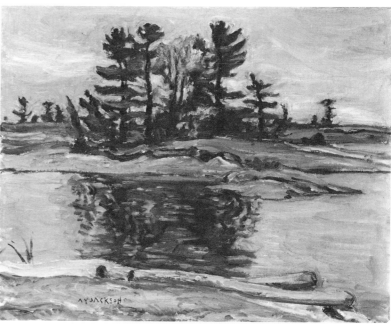

Oil on panel, 26.7 x 34.3 cm

Signed

NJG 968

Private collection

PROVENANCE
Acquired from the Walter Klinkhoff Gallery 1965.

EXHIBITION
Montreal, Walter Klinkhoff Gallery, November 1965
[*Baffin Island Paintings by A.Y. Jackson*], No.14.

The work is signed, titled, and dated on a label verso. The canvas is in the same collection.

Oil on panel, 26.7 x 34.3 cm

Signed lower left: A Y JACKSON

NJG 1287

Ontario Heritage Foundation,
Firestone Art Collection, Ottawa

PROVENANCE
Acquired from the artist.

LITERATURE
Firestone, Jackson No.256, p.86.

The work is titled and dated verso.

81

Notre Dame de la Salette, Quebec
February 1968

Oil on panel, 26.7 x 34.3 cm

Signed lower left of centre: A Y JACKSON

NJG 1377

Private collection

PROVENANCE
Acquired from the artist 1968.

The work is signed, titled, and dated verso.

Chronology

compiled by Naomi Jackson Groves

"Spring must be here – A. Y. Jackson is back." So Pearl McCarthy, art critic for *The Globe and Mail*, would respond to his return to Toronto with a new crop of sketches.

Her words show with what seasonal regularity Jackson came and went, and worked – almost like a migratory bird.

For more than forty years his spartan quarters in the Studio Building on Severn Street meant home to him. He took most of his meals in the Tom Thomson shack out back with his good friend Keith MacIver and Brownie, the dog; several times a week he was out to dinner at various hospitable homes.

His regular sketching expeditions took him away for weeks or months at a time. Until 1947, for instance, every March/April, he went to the Lower St. Lawrence, either North Shore or South but never both in the same season. After 1947, he transferred his allegiance to the countryside around Ottawa, with its ice-bound tributaries east and west of the capital, near which he settled in 1955. Each sketching trip, which could result in up to fifty oil sketches on wood panels, began and ended with stopovers to visit relatives and friends in Montreal and Ottawa; then he returned to the Toronto, and later the Manotick, studio to paint his canvases.

Just as regularly, summers belonged to Georgian Bay for at least a month or six weeks; staying with his many friends on their lovely islands, he combined summer sports and lively sociability with quite a bit of sketching. In 1955, he became a landowner, not only near Ottawa but also on Lake Superior near Wawa, where he had his own little log cabin next to the country home of Toronto friends. Thereafter, the summers were shared between the contrasting landscapes of Georgian Bay and Lake Superior.

During many Septembers in the 1930s and 1940s, he would spend a pleasant fortnight or so at the homes of old Montreal and Ottawa artist friends at Fernbank on the St. Lawrence near Brockville, with plenty of in-between visits to other Ontario and Quebec sketching areas. Later in the autumn he liked to be in wilder country farther north in Ontario, often up in the La Cloche Hills area east of Espanola. (He called it "Algoma," maybe because it was part of the political riding of Algoma East, which was held for years by Mike Pearson.)

In later years, the West began to claim him in the fall. He liked the rolling ranchland of southern Alberta, where the Porcupine Hills lead to the foothills and then to the Rockies. He nearly always made his headquarters at the cosy home of his brother Ernest, in Lethbridge, stopping en route with a nephew or niece in Calgary.

Between 1943 and 1949, he taught six summer sessions at the Banff School of Fine Arts. Here, many of his students became friends who took him to their homes – in Canmore, Kamloops, in the Cariboo 150 miles north of Ashcroft (hence the "150 Mile House" of gold-rush days). Or he might be found in southern Alberta with friends in the country around Calgary, Pincher Creek, and Waterton Lakes.

Far-distant fields attracted him, as well – his compass always pointed north, he said: Great Bear Lake in 1938, and later often opening up wonderful new working areas by plane or helicopter. It was the Yukon and Alaska in 1943 and, even more satisfactorily, in 1964; Northern Labrador in 1961 and 1962. The Eastern Arctic, to which he had journeyed by boat laboriously, in 1927 and 1930, called him back in 1965, in his eighty-third year. On this last Arctic trip he produced more than thirty fine sketches while camping in an unheated tent for a month on the Baffin permafrost behind Pangnirtung. Here he painted the mountains that were being climbed – and named – by his Alpine Club companions, fifty to sixty years his junior.

The winter solstice always saw him with the family at one of the three Jackson homes, first in Montreal and later around Ottawa. On these occasions he caught up on the latest news of his artist friends and always visited a veteran pal from the First World War.

Added to all these routine travels were frequent trips back and forth across Canada to receive honorary degrees, or to help open an exhibition, or to give his famous and always entertaining talk on the Group of Seven. ("The slide's in backwards? Oh well, we'll have to call it 'East of Rosebud' instead of 'West of. . . .'")

His deepest allegiance was to art – his own, his friends', his country's. But his widest allegiance was to the dozens of families across the country whose children called him Uncle Alex and shouted with pleasure when he arrived. He never lost the vigour of his personality, even after being partially paralysed in 1968. If he thought about it at all, he probably thought, Never say die. The other birds that migrate by instinct never say die, either. Like them, he was a force of nature.

NJG
January 1982

1933

MARCH–APRIL
Charlevoix County, principally at St. Urbain.

SUMMER
Camped with friends, including Anne Savage, on the Western Islands in Georgian Bay.

OCTOBER
Camped alone in La Cloche Hills region northwest of Georgian Bay.

1934

MARCH
Quebec City and region.

APRIL
St. Joachim and St. Tite des Caps on the North Shore of the St. Lawrence.

JULY
By July 3 on Cape Breton Island with Toronto painters Peter and Bobs C. Haworth.
By July 28 on Georgian Bay.

AUGUST
Camped with his niece and a friend on Pine Island, Georgian Bay.

SEPTEMBER
Brockville, Ontario, by September 15.

OCTOBER
Georgian Bay, and at Grace Lake in the La Cloche Hills region.

1935

MARCH–APRIL
South Shore of the St. Lawrence, in the region of St. Fabien, Rimouski County. Albert Cloutier was with him for three weeks in March. At Cacouna for three days in April.

JUNE
Georgian Bay.

JULY–AUGUST
Tadoussac at the mouth of the Saguenay River on the North Shore of the St. Lawrence.

SEPTEMBER
Georgian Bay by September 2.

OCTOBER
Cobalt, Ontario.

1936

MARCH–APRIL
Fox River, Gaspé.

MAY
At the end of May left with graduate-student niece by boat for Europe and to attend a reunion of army veterans in England. Mr. and Mrs. Arthur Lismer and their daughter Marjorie travelled on the boat as well. Stayed in Europe less than six weeks, visiting Paris and travelling in Belgium, Germany, and England.

OCTOBER
Georgian Bay by October 12.

NOVEMBER
New York City over US Thanksgiving week-end.

1937

MARCH–APRIL
North Shore of the St. Lawrence. Worked at St. Tite des Caps with Dr. Frederick Banting.

JULY 23 TO AUGUST 4
Visited with friends on Georgian Bay.

AUGUST
Alterations to Toronto studio August and September. Camped on Pine Island, Georgian Bay.

SEPTEMBER
Brockville with the Hewards of Montreal.

END OF SEPTEMBER TO MID-NOVEMBER
Southern Alberta, used his brother Ernest's home in Lethbridge as base, visited principally the extreme southwest in the region of Pincher Creek, Cowley, and Lundbreck.

1938

MARCH
Around March 19 visit to Cedar Point near Georgian Bay.

APRIL
Washington, D.C.

MAY
Grace Lake in the La Cloche Hills region.

JULY 14-28
Visited friends on Georgian Bay.

AUGUST 26 TO END OF SEPTEMBER
Eldorado Mines at Port Radium on Great Bear Lake, Northwest Territories.

FIG. 5
At Cowley, Alberta, c. 1938.

OCTOBER
Southern Alberta.

1939

MARCH 16 TO APRIL 25
South Shore of the St. Lawrence in the region of Rimouski County. Visited villages of Bic and St. Simon, and stopped at St. Léonard, St. Hyacinthe, and Hull on his return.

JUNE
Late June to Espanola in the La Cloche Hills region.

JULY
By July 6 to Georgian Bay.

AUGUST
By August 5 at New York World's Fair to help install the Canadian Group of Painters exhibition.

SEPTEMBER
Grace Lake in the La Cloche Hills region.

1940

MARCH–APRIL
L'Islet County on the South Shore of the St. Lawrence; stayed in the village of Ste. Louise.

JULY
Georgian Bay.

OCTOBER
Gem Lake in the La Cloche Hills region with Graham McInnes, Budge Crawley and his film crew to shoot about ten days of autumn scenes for the National Film Board production on Jackson, *Canadian Landscape* (released in 1942).

1941

MARCH–APRIL
St. Tite des Caps and La Malbaie on the North Shore of the St. Lawrence to film more of *Canadian Landscape*.

MAY
Smoke Lake, Algonquin Park, assisted with the National Film Board production on the life and work of Tom Thomson, *West Wind* (released in 1943).

JUNE
The Canadian Conference on the Arts, Kingston.

JULY
By July 19 on Georgian Bay.

AUGUST
Quebec City and Montreal at the end of the month making drawings for Henry Beston's *The St. Lawrence* (New York and Toronto: Farrar & Rinehart, Inc., 1942).

OCTOBER 17
LL.D. from Queen's University, Kingston.

1942

MARCH–APRIL
Area of St. Pierre de Montmagny in Montmagny County on the South Shore of the St. Lawrence with Randolph Hewton.

OCTOBER 20 TO NOVEMBER 11
With brother H.A.C. Jackson in region of his country home at St. Aubert in L'Islet County on the South Shore.

1943

MAY 3 TO JUNE 1
With brother H.A.C. Jackson again in region of St. Aubert in L'Islet County on the South Shore.

JULY
Briefly on Georgian Bay the first week.

SUMMER
Taught at the Banff School of Fine Arts.

SEPTEMBER
Sketched at Canmore and Rocky Mountain House, Alberta, and at the end of September stopped briefly in Waterton Park in the extreme southwest corner of Alberta. In each case stayed with friends who were his students at Banff.

OCTOBER
Travelled the newly built Alaska Highway with H.G. Glyde, under the auspices of the National Gallery of Canada, although the painters were the guests of the United States Army.

NOVEMBER
Stopped again at Lethbridge before returning to Toronto.

DECEMBER
Ottawa regarding program of silk-screen reproductions for Armed Forces.

1944

21 MAY TO 10 JUNE
Stayed with his brother at St. Aubert. Stopped briefly in Montreal on his return.

SUMMER
Taught at the Banff School of Fine Arts. Visited Canmore, nearby, and subsequently travelled to region of Kamloops, British Columbia. Still there in early September. Visited Vancouver.

SEPTEMBER–OCTOBER
Lethbridge and Waterton Park. By September 22 in Rosebud, Alberta. Plans to return to the Alaska Highway had fallen through. Stopped over in Regina to address Women's Canadian Club (October 31), opened Canadian Federation of Artists Exhibition (November 1), to Winnipeg November 2 to address Federation there.

1945

MARCH 29 TO MAY 8
At the H.A.C. Jackson family country home at St. Aubert.

SUMMER
Taught at the Banff School of Fine Arts.

SEPTEMBER TO NOVEMBER
Late in the month to Kamloops, Ashcroft, and then to the Cariboo region of British Columbia, including Barkerville, with friends at 150 Mile House near Williams Lake for six weeks. Finally to southern Alberta, visited, among other places, Pincher Creek and Millarville. Back to Toronto November 9.

1946

JANUARY
Short trip to Ottawa.

FEBRUARY
Returned to Ottawa and area.

MARCH–APRIL
From March 17 at St. Tite des Caps on the North Shore. Arrived in Montreal April 11 and stopped briefly before returning.

SUMMER
Taught at the Banff School of Fine Arts.

SEPTEMBER
By September 2 with friends at their Bar X Ranch near Pincher Creek in southwestern Alberta.

OCTOBER
The Cariboo region of British Columbia.

DECEMBER 14
Companion of the Order of Saint Michael and Saint George (CMG), Ottawa.

1947

MARCH 18 TO APRIL 23
Port au Persil near St. Simeon in Charlevoix County on the North Shore. Spent a week in La Malbaie, and stopped in Montreal en route from and to Toronto.

MAY
Haliburton late in the month.

SUMMER
Taught at the Banff School of Fine Arts.

FIG. 6
Landscape class at the Banff School of Fine Arts, summer, c. 1946. Florence Strong of Ottawa is observing the teacher.

SEPTEMBER
Stayed in Canmore, and then travelled in to the Cariboo region of British Columbia, visited Ashcroft and Williams Lake.

OCTOBER
Pincher Creek, Waterton Park, Cowley, and other places in southern Alberta.

1948

FEBRUARY
Short trip to Ottawa.

MARCH
Sketched up the Gatineau River north of Ottawa for two and a half weeks with friends.

MAY
Sudbury and Copper Cliff, north of Georgian Bay.

JULY
Visited his brother's family at St. Aubert for two weeks.

OCTOBER
Back to the Ottawa-Gatineau region, October 8-25.

1949

MARCH
Sketched up the Gatineau River for two and a half weeks. Stopped in Montreal.

APRIL–MAY
Left April 20 for the Cariboo region of British Columbia, including Barkerville on May 23.

JUNE
By June 20 at Bar X Ranch near Pincher Creek in southwestern Alberta.

SUMMER
Taught at the Banff School of Fine Arts.

SEPTEMBER
Port Radium region on Great Bear Lake with Maurice Haycock for the federal Department of Mines and Resources. Stopped at Yellowknife on Great Slave Lake on return south. Left Lethbridge for Toronto mid-October.

1950

MARCH
Sketched in the Gatineau region, as far east as Ripon.

AUGUST–SEPTEMBER
Port Radium on Great Bear Lake. August 23-28 camped near the Teshierpi Mountains on the Barren Lands. Returned to Port Radium, and from there visited Cameron Bay, Cobalt Island, and McDonagh Lake. Stopped at Yellowknife on return south.

LATE SEPTEMBER–OCTOBER
Calgary and Lethbridge in southern Alberta. At Twin Butte October 17.

NOVEMBER
Visited friends' cottage on Georgian Bay.

1951

JANUARY 10-15
Montreal.

MARCH 17 TO APRIL 8
Sketched up the Gatineau River. Stopped in Montreal until April 17. Lilias Torrance Newton was using his Toronto studio.

JUNE 21
Presented with the "National Award for Art," University of Alberta, Edmonton.

JULY
Georgian Bay.

AUGUST–SEPTEMBER
Great Bear Lake. By August 15 camped on the Barren Lands near September Mountains with John Rennie. To Hunter Bay area by August 20. Travelled about the region, including a flight to Coppermine September 7. En route out, in Yellowknife September 20.

OCTOBER
Southern Alberta, probably Calgary area until mid-month. Returned with a stop at La Rivière, Manitoba, and perhaps at Kirkland Lake, in northern Ontario.

1952

FEBRUARY
Mount Allison University, Sackville, N.B.

APRIL
Madsen Gold Mines at Red Lake, near Kenora, Ontario.

JULY 10-28
St. John's, Newfoundland to fulfil commission with Seagram's Cities of Canada project.

AUGUST
With friends on West Wind Island and North Pine, Go Home Bay, Georgian Bay.

OCTOBER 5-30
Lecture tour with Frances Loring in the Peace River region of British Columbia, under auspices of National Gallery of Canada. Stopped in Manitoba on return.

SEPTEMBER 22 TO OCTOBER
Barry's Bay, east of Algonquin Park.

1953

MARCH 24 TO APRIL 23
Mont Joli region of Gaspé with Maurice Haycock, principally to visit Consolidated Candego Mines.

JUNE–JULY
West Wind Island, Georgian Bay.

AUGUST 27–SEPTEMBER 7
Region of St. Aubert on the South Shore, visited St. Onésime, St. Gabriel, St. Damase. Ottawa area at the end of the month.

OCTOBER 16
LL.D. from McMaster University, Hamilton, Ont.

OCTOBER–JANUARY
Toronto-Ottawa-Montreal in connection with his retrospective exhibition.

1954

MARCH–MAY
Victoria, B.C., then Cariboo region. Southern Alberta, Waterton Park, and Pincher Creek area, and British Columbia interior.

JULY
Georgian Bay.

AUGUST
Sault Ste. Marie and along east shore of Lake Superior to Wawa with friends. Purchased land at Manotick near Ottawa with plans to construct a new studio there.

1955

MARCH
Vacated Studio Building and left Toronto to settle in new studio at Manotick.

APRIL 3-13
Sketched at Gracefield in Gatineau region.

FIG. 7
West Wind Island, Georgian Bay, July 4, 1953.

FIG. 8
Sketching on Goulais River, Algoma, 1955.

FIG. 9
On Lake Superior, near Wawa, late 1950s.

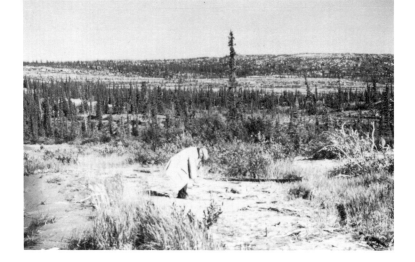

FIG. 10
Collecting chips for the fire, Hornby Bay, Great Bear Lake, August 20, 1959.

JULY
Georgian Bay.

AUGUST
East shore of Lake Superior with friends. Shared in purchase of land on Twidale Bay at Wawa to build cabin near friends' summer house, "Rossay."

SEPTEMBER–OCTOBER
Sketched in Algoma region near Sault Ste. Marie.

NOVEMBER
Sketched in Ottawa Valley area with Ralph Burton.

1956

FEBRUARY–MARCH
Trinidad and Tobago with artist friends from Toronto.

APRIL
Sketched up the Ottawa River with Ralph Burton.

SUMMER
Go Home Bay, Georgian Bay.

LATE SEPTEMBER–OCTOBER
Algoma, with stops at Sault Ste. Marie and Wawa.

NOVEMBER
Accepted honourary membership in Royal Cana-

dian Academy of Arts. He had resigned in December 1932.

1957

MARCH 8-12
Hamilton.

MARCH 18–APRIL 3
Sketched around Ste. Adèle, north of Montreal, with nieces.

MAY 3-10
Sudbury.

MAY 17
LL.D. from Carleton University, Ottawa.

SUMMER
Go Home Bay, Georgian Bay.

AUGUST 28 TO OCTOBER 13
Flew to Yellowknife on Great Slave Lake, out on Barren Lands, and to Gunnar Mines in Uranium City region of northern Saskatchewan on Lake Athabaska, with Maurice Haycock.

1958

FEBRUARY–MARCH
Sketched up the Ottawa in Lanark County and at Lake Clear, at country home of Ottawa friends.

APRIL 7-14
Morin Heights, north of Montreal.

MAY
Guelph, Ontario. 10-22, Lake Superior around Wawa.

AUGUST
Georgian Bay.

OCTOBER 5-12
Eastern Townships.

NOVEMBER
A Painter's Country published.

1959

MARCH 8
Awarded Freedom of the City of Toronto.

APRIL
Sketched around St. Adèle, north of Montreal, with nieces and friends. Later, sketched in Ottawa Valley.

JUNE 17-23
Guelph, Ontario for unveiling his mural at Ontario College of Agriculture.

JULY
Lake Superior around Wawa.

AUGUST 3-10
Georgian Bay.

AUGUST–SEPTEMBER
Flew with Maurice Haycock to Uranium City area on Lake Athabaska in northern Saskatchewan, then to Great Slave Lake and to Port Radium on Great Bear Lake. To Hornby Bay and Atnick Lake by helicopter. September 9-16 in region of Lake Rouvière in the Barrens. To Bathurst Inlet on the Arctic coast. In Lethbridge, Alberta, by September 27.

OCTOBER
Georgian Bay by October 13. Back in Manotick by October 18.

1960

MARCH–MAY
Sketched around Ottawa Valley, at Calabogie, Ontario, March 22 and April 15; Ripon, Quebec, April 9-14.

JULY
Lake Superior around Wawa.

AUGUST
Georgian Bay.

OCTOBER
Sketched around Combermere and along Madawaska River, northwest of Ottawa.

1961

JANUARY 2-12
Toronto, Streetsville, and Guelph.

SPRING
Sketched in Ottawa Valley region: Killaloe, Calabogie, Ripon.

MAY 27 TO JUNE 15
Labrador with Maurice Haycock, stopped at Schefferville for about ten days and the balance at Carol Lake.

JULY
1-13, Georgian Bay, then Rock Island, Quebec with Henrietta Banting.

AUGUST
Georgian Bay.

SEPTEMBER
Wawa.

OCTOBER
Sketched northwest of Ottawa.

NOVEMBER 24-27
Toronto and Sarnia (Women's Art Association).

DECEMBER 2
Cowansville, Quebec.

1962

FEBRUARY 19
Canada Council Medal for 1961, presented in Ottawa.

SPRING
Left Manotick studio and moved to 192 Maclaren Street in Ottawa.

JUNE
Schefferville and Carol Lake in Labrador.

JULY 15-30
Lake Superior around Wawa.

AUGUST
Georgian Bay.

SEPTEMBER
Muskoka district, east of Georgian Bay.

NOVEMBER 17
LL.D. from University of Saskatchewan, Saskatoon.

1963

MARCH 25 TO APRIL 10
Notre Dame de la Salette in the Ottawa-Gatineau region. Later in April at Brantford.

JUNE 4-10
St. Césaire, Quebec.

AUGUST
Georgian Bay.

SEPTEMBER 24 TO OCTOBER 15
Sketched in the Ottawa Valley region around Combermere.

1964

FEBRUARY 27 TO MARCH 1
Sketched at Ste. Agathe north of Montreal with Sam Borenstein.

MARCH 20-28
Lake Clear, west of Ottawa, with Ralph Burton.

JULY
Short visit to Canoe Lake, Algonquin Park.

AUGUST
Georgian Bay.

SEPTEMBER 9 TO OCTOBER 30
The Yukon and Alaska with Ralph Burton and Maurice Haycock.

NOVEMBER 19
Port Arthur for Group of Seven show, some sketching.

1965

MARCH 20 TO APRIL 12
Sketched in Ottawa-Gatineau region, staying in Grenville, Quebec with friends.

JUNE
Riviere Ouelle, St. Onésine, L'Islet County on the South Shore of the St. Lawrence with Sam Borenstein.

JULY
Baffin Island with members of the Alpine Club of Canada, camped north of Pangnirtung for a month.

AUGUST
Lake Superior around Wawa.

SEPTEMBER
Sketched at Buckingham, Quebec, northeast of Ottawa.

OCTOBER
Lake Clear, west of Ottawa.

1966

MARCH–APRIL
Sketched in Ottawa-Gatineau area.

MAY
Lake Clear.

JUNE 1
LL.D. from University of British Columbia, Vancouver.

JULY
Wawa for three weeks.

AUGUST
Go Home Bay on Georgian Bay.

SEPTEMBER–OCTOBER
Ottawa-Gatineau area.

DECEMBER 28
Toronto and Kleinburg.

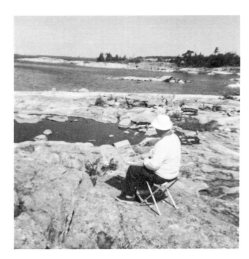

FIG. 11
Sketching on Georgian Bay, summer 1967.

FIG. 12
Sketching at Notre Dame de la Salette, Quebec,
February 26, 1968.

FIG. 13 Greeting visitors to the Jackson Room, McMichael Canadian Collection, Kleinburg,
with Zita Wilson, his nurse-companion, 1970.

1967

MARCH–APRIL
Sketched in Ottawa-Gatineau region, with six days in Ripon.

JUNE 2
D. Litt. from McGill University, Montreal. Later in month sketched in Lake Clear region.

JULY–SEPTEMBER
Go Home Bay on Georgian Bay.

SEPTEMBER–OCTOBER
Motor trip to Lower St. Lawrence and New Brunswick with Ralph Burton.

OCTOBER
Lake Clear, and then on to Opeongo Lake in Algonquin Park.

NOVEMBER
Sketched at Notre Dame de la Salette, northeast of Ottawa, staying with a friend in Buckingham, Quebec.

DECEMBER 28 TO JANUARY 8
Toronto area.

1968

FEBRUARY
Sketched at Notre Dame de la Salette.

MARCH
Sketched in Ottawa area at Ripon and Grenville.

APRIL
Suffered a stroke, April 22, resulting in partial paralysis. Companion of the Order of Canada, accepted on his behalf by his niece, Naomi, April 26.

JUNE
Moved to an apartment in the McMichael Conservation Collection in Kleinburg, north of Toronto, at the invitation of Robert and Signe McMichael.

1973

JANUARY
Moved to Pinegrove Nursing Home at Woodbridge.

1974

APRIL 6
Died in ninety-second year. Buried in the McMichael grounds at Kleinburg, near the graves of other members of the Group of Seven.

Bibliography

Compiled by Carol Lowrey

The following bibliography and listing of exhibitions is to be used in conjunction with Dennis Reid's *Bibliography of the Group of Seven* (Ottawa: National Gallery of Canada, 1971). Titles omitted from that work have been included here in addition to selected material appearing since its publication. Following the format of the original work, this bibliography has been divided into two sections: individual citations and exhibitions with reviews.

1917 "Artist to Sketch Battlefields of Canadian Forces." *Montreal Star*, 4 September 1917.

"Will Paint Battle Fields in Europe: A.Y. Jackson, A.R.C.A., Appointed by Canadian War Records Office as Artist." *Montreal Gazette*, 4 September 1917.

1921 "Public Profession of Artistic Faith." *Montreal Gazette*, 18 January 1921.

"Studio Talk: Toronto." *The Studio* 82 (October 1921): 166-70.

1924 "A.Y. Jackson's Picture for National Gallery." *Toronto Star*, 23 October 1924.

"Painting by Canadian Artist will Hang in National Gallery." *Toronto Globe*, 24 October 1924.

1925 Grier, Wyly and Jackson, A.Y. "Two Views of Canadian Art." In *Addresses of the Empire Club of Canada*, pp. 97-113. Toronto: The Club, 1925.
Address delivered 26 February 1925.

"Empire Club Hears Views of Two Artists on Art." *Toronto Star*, 26 February 1925.

"Rival Schools of Art Stoutly Championed: E. Wyly Grier and A.Y. Jackson Air Views Before Empire Club." *Mail and Empire* (Toronto), 27 February, 1925.

Jackson, A.Y. " 'Group of Seven' Painter Answers Sir John Collier." *Toronto Star*, 23 May 1925.

1926 "Still Look to France for Art Developments: A.J. [sic] Jackson Addresses Women's Art Association." *Toronto Star*, 13 January 1926.

1927 "Expedition Anchored in Greenland Harbor: Dr. Banting and A.Y. Jackson Make Sketches from Deck of Beothic." *Mail and Empire* (Toronto), 27 July 1927.

"Mr. Jackson Sketches Farthest North, Where Canadian Mounties Patrol the Roof of the World." *Toronto Star*, 10 September 1927.

"Have to substitute Pines for Models: Canadian Artists Must Turn to Nature for Inspiration Jackson Says." *Toronto Star*, 8 November 1927.

1937 C., F.G. (Cross, Frederick G.), "Distinguished Canadian Painter, Alexander Young Jackson, Gets South Alta. Scenes on Canvas." *Lethbridge Herald*, 13 November 1937.

1941 Buckman, Eduard. "Canadian Landscape: A New Film of an Artist at Work." *Magazine of Art* 34 (October 1941): 428-29.

1942 G., H.B. "Roaming with A.Y. Jackson." *Winnipeg Free Press*, 28 March 1942.

1943 " 'Group of Seven' Artist Delighted with West: Dr. A.Y. Jackson Will Return to Exhibit in Calgary." *Calgary Herald*, 30 September 1943.

"Artist Finds West Good for Pictures." *Edmonton Journal*, 21 October 1943.

1944 "Famous Artist Paints Canadian Northland Recording Changes Seen in New Film." *New Glasgow* [N.S.] *Evening News*, 2 March 1944.

Jackson, A.Y. "Art in Living." *Bulletin of the Vancouver Art Gallery* 12 (October 1944): 3.

1945 "Dr. A.Y. Jackson Artists' Guest: Describes Rich Beauties of Canada's Sketching Grounds." *Hamilton Spectator*, 23 February 1945.

"Artist Recalls Epic of 'Seven.'" *London Evening Free Press*, 15 March 1945.

1947 "Art and Change." *London Evening Free Press*, 1 March 1947.

1948 "Dr. A.Y. Jackson Recalls Trials of Canadian Painters Widely Known as Famous Group of Seven." *Oshawa Independent*, 11 March 1948.

"Ottawa Area Ideal for Artist Says A.Y. Jackson, Famous Painter." *Ottawa Evening Journal*, 13 March 1948.

1949 "Teachers Advised on Art Changes." *St. Catharines Standard*, 17 February 1949.

Bletcher, Betty. "Noted Artist Urges Creative Work for Young Canadians." *Lethbridge Herald*, 31 October 1949.

McCarthy, Pearl. "Wide Interest in Art Found in Remote Areas." *Globe and Mail* (Toronto), 15 November 1949.

1950 "Queen's Art Exhibition Opens with A.Y. Jackson as Speaker." *Kingston Whig-Standard*, 1 February 1950.

"Famous Painter Frowns on New Abstract Trends." *Kitchener-Waterloo Record*, 3 June 1950.

"Prominent Canadian Artist Finds Alberta 'Very Exciting'". *Lethbridge Herald*, 28 October 1950.

McCarthy, Pearl. "A.Y. Jackson is Home from Trip to Badlands." *Globe and Mail* (Toronto), 20 November 1950.

1951 "Famed 'Seven' Member Jackson Urges Sanity in Painting." *Ottawa Evening Journal*, 4 April 1951.

Goldblatt, Murray. "Artist Jackson Charms Students at Nepean High." *Ottawa Evening Citizen*, 6 April 1951.

"Landscape Art No Longer Sourdough Stuff." *Ottawa Evening Journal*, 6 April 1951.

"A. Jackson to Review Four Paintings." *The Varsity* (Toronto), 5 December 1951.

"Discusses Group of Seven's Effect on Canadian Art." *Hamilton Spectator*, 14 December 1951.

1952 "Canadian Artists End an Experiment: Painter, Sculptress in City after West Visit." *Winnipeg Free Press*, 5 November 1952.

1953 "Outspoken A.Y. Jackson considers National Gallery Quarters 'Awful.'" *Ottawa Evening Journal*, 14 December 1953.

1954 "Canada Painter's Country, Art Dean Tells Londoners." *London Evening Free Press*, 16 January 1954.

Quayle, Jean. "Famed Canadian Artist

Discusses Painting Here." *Montreal Herald*, 28 January 1954.

Ayre, Robert. "A.Y. Jackson: Vital Artist." *Montreal Star*, 30 January 1954.

Johnson, Audrey St. D. "Member of 'Group of Seven' Says Art Gaining in Canada." *Victoria Daily Times*, 20 April 1954.

Huckvale, Jane. "Dr. A.Y. Jackson Sees Possibilities in Northland for Prairie Artists." *Lethbridge Herald*, 15 May 1954.

1955 McCarthy, Pearl. "Jackson Quits Noted Toronto Studio." *Globe and Mail* (Toronto), 4 January 1955.

"Painter A.Y. Jackson Taking Up Residence in New Manotick Home." *Ottawa Citizen*, 4 January 1955.

Weiselberger, Carl. "Manotick – New Art Mecca?" *Ottawa Citizen*, 5 January 1955.

"A.Y. Jackson's Relatives Happily Await Arrival of Famed 'Uncle Alex' at Manotick." *Ottawa Evening Journal*, 8 January 1955.

"Artists Return from Excursion to Gracefield." *Ottawa Evening Journal*, 16 April 1955.

Delzell, Sylvia. "Art Brushes." *Hamilton Spectator*, 25 June 1955.

"A.Y. Jackson and Maurice Haycock on Sketching Outing in Algoma District." *Ottawa Evening Journal*, 1 October 1955.

"Algoma's Charm Lures Famous Painter." *Sault Ste. Marie Daily Star*, 8 October 1955.

1957 Ketchum, W.Q. "A.Y. Jackson Heads Out with Friends to Paint Rugged North." *Ottawa Journal*, 30 August 1957.

1958 "Famous Artist Painting Scenes of OAC Campus." *Guelph Mercury*, 30 October 1958.

Crawford, Lenore. "A.Y. Jackson Gives Views at Art Mart." *London Free Press*, 29 November 1958.

Jackson, A.Y. "'Letters to the Editor' Observations by a Painter." *Ottawa Citizen*, 26 December 1958.

1959 "Avenir brillant de la peinture dans notre pays." *Le Droit* (Ottawa), 20 February 1959.

Crawford, Lenore. "A.Y. Jackson's 'A Painter's Country' Retains Honesty, Courage of Artist." *London Free Press*, 28 March 1959.

Hubbard, R.H. "Four New Books on Canadian Art." *Canadian Art* 16 (May 1959): 127-29. (Review of *A Painter's Country*).

"'Arts and Letters' Portrait of the Artist." *Time* (Canada), 28 September 1959.

"Veteran Painter Vigorous at 77." *Quebec Chronicle-Telegraph*, 24 November 1959.

1960 Kent, N. "Two Canadian Masters of Landscape." *American Artist* 24 (March 1960): 20-21.

"A.Y. Jackson Sees Art Flourishing." *Ottawa Journal*, 2 March 1960.

North, Scott. "At 78, His Output is Still the Envy of Younger Painters." *Ottawa Journal*, 1 October 1960.

1961 Bedard, M.-F. "M. A.Y. Jackson Parle du fameux Groupe des 7." *Le Droit* (Ottawa), 17 January 1961.

Finlay, Thelma. "Dr. A.Y. Loves to Paint Canadian . . ." *Brantford Expositor*, 28 March 1961.

"It's Art Gone Mad – Critico." *Toronto Telegram East, Suburban Living*, 15 November 1961.

1964 "A.Y. Jackson Would Make Bars Horizontal, Wavy." *Ottawa Journal*, 26 June 1964.

"At 82, A.Y. Jackson Again Treks Yukon." *Toronto Telegram*, 29 September 1964.

"A.Y. Jackson Recalls Wandering at Unveiling of Paintings Here." *Kingston Whig-Standard*, 3 December 1964.

1965 Kritzwiser, Kay. "Work is Mr. Jackson's Discipline." *Globe and Mail* (Toronto), 7 August 1965.

1966 Arnason, Al. "Jackson on the Fence too." *Vancouver Province*, 1 June 1966.

1967 "A.Y. Jackson Praised for Wartime Sketches." *Ottawa Citizen*, 23 January 1967.

"Painter Says Abstracts Doomed." *Ottawa Citizen*, 22 March 1967.

1968 Kritzwiser, Kay. "A.Y. Jackson, Lively Old Master Sees Gallery of His Works Opened." *Globe and Mail* (Toronto), 23 September 1968.

Ballantyne, Michael. "A Fascinating Record, A.Y. Jackson's Canada." *Montreal Star*, 23 November 1968.

1969 Robertson, Gillian. "A.Y. Jackson, Chirpy Scene-stealer at 87." *Toronto Telegram*, 2 October 1969.

1970 Lord, Barry. "A.Y. Jackson: At 87 an Artist Still Must Paint." *Toronto Star*, 10 January 1970.

"Academy Medal for A.Y. Jackson." *Toronto Telegram*, 31 January 1970.

Edwards, Alyn. "Group of Seven's A.Y. Jackson Honored." *Toronto Telegram*, 30 March 1970.

Kritzwiser, Kay. "Names and Memories from Jackson." *Globe and Mail* (Toronto), 26 May 1970.

Groves, Naomi Jackson. "Jackson's Pencil Drawings: A Family Recollection." *Canadian Antiques Collector* 5 (July – August 1970): 16-18.

Haycock, Maurice. "A Northern Tribute to A.Y Jackson." *North* 17 (September – October 1970): 38-41.

1972 Kritzwiser, Kay. "Homage to A.Y. Jackson on the Occasion of His 90th Birthday, October 3, 1972." *Globe and Mail* (Toronto), 30 September 1972.

Dupuy, Michel. "A.Y. Jackson a 90 ans." *Le Droit* (Ottawa), 7 October 1972.

Grantham, Ronald. "A.Y. on A.Y. Interesting Experience." *Ottawa Citizen*, 4 November 1972.

1973 Davidson, True. "The Creative Artist: A.Y. Jackson." *The Golden Strings*, pp. 93-102. Toronto: Griffin House, 1973.

"Alberta Gets Eighteen Drawings by Jackson." *Globe and Mail* (Toronto), 30 March 1973.

"A.Y. Jackson Aims for 100th Birthday." *Ottawa Citizen*, 5 October 1973.

1974 "A.Y. Spent 70 Years Portraying the Face of Canada." *Toronto Star*, 5 April 1974.

"Group of Seven's A.Y. Jackson Dies at 91." *Toronto Star*, 5 April 1974.

"A.Y. Jackson Saw Canada Clearly." *Toronto Star*, 6 April 1974.

Fulford, Robert. "A.Y. Jackson: A Heroic Age Ends." *Toronto Star*, 6 April 1974.

Irving, Kit. "What Canada Lost in A.Y. Jackson." *Ottawa Journal*, 6 April 1974.

Kritzwiser, Kay and McCarthy, Pearl. "Last of Group of Seven a Giant in Canadian Art." *Globe and Mail* (Toronto), 6 April 1974.

Timson, Judi. "Paper Roses for Jackson from Three Sisters." *Toronto Star*, 8 April 1974.

"A.Y. Jackson is Buried Near Collection of His Art." *Montreal Star*, 9 April 1974.

Kritzwiser, Kay. "Bright Memories at Final Rites." *Globe and Mail* (Toronto), 9 April 1974.

Lowman, Ron. "Friends Exchange Fond Tales at Jackson's Funeral." *Toronto Star*, 9 April 1974.

Toupin, Gilles. "La mort de Jackson." *La Presse* (Montreal), 11 April 1974.

Royer, Jean. "Comme quoi les revolutions. . . ." *Le Soleil* (Quebec), 12 April 1974.

1977 McDougall, Anne. *Anne Savage: The Story of a Canadian Painter*. Montreal: Harvest House, 1977.

1978 Tyrwhitt, J. "A.Y. Jackson: All Canada for his Canvas." *Reader's Digest* (Canada) 112, (April 1978): 43-48.

1979 Banting, Frederick. "Diary and Drawings of Eastern Arctic Expedition, 1927, with A.Y. Jackson." *Northward Journal* 14/15 (1979): 25-35.

Banting, Frederick. "Diary and Drawings of Western Arctic Expedition, 1928, with A.Y. Jackson." *Northward Journal* 14/15 (1979): 36-58.

Firestone, O.J. *The Other A.Y. Jackson: A Memoir*. Toronto: McClelland and Stewart, 1979.

Walker, Kathleen. "A.Y. Jackson Recalled." *Ottawa Citizen*, 21 December 1979.

1980 Tovell, Rosemarie L. "A.Y. Jackson in France, Belgium and Holland: A 1909 Sketchbook." *National Gallery of Canada Annual Bulletin* 2 (1980): 31-51.

Exhibitions

1914
Montreal
The Arts Club, 9–30 May 1914, *Exhibition of Paintings by Mr. A.Y. Jackson, Toronto*. A numbered check list was published.

1944
Calgary
Calgary Art Association, Coste House, 6–20 May 1944 [*H.G. Glyde and A.Y. Jackson, Alaska Highway Sketches*].

REVIEW
Lent, Geneva D. "Artist Finds Human Interest Along the Alaskan Highway." *Calgary Albertan*, 8 May 1944.

Toronto
Eaton's Fine Art Galleries, 17–27 May 1944, *Wartime Paintings of the West Coast and the Alaska Highway: An Official War Records Assignment*. Jackson oils of Alaska Highway and water colours of the West Coast by Peter and Bobs Cogill Haworth.

REVIEWS
"Saga of Alaskan Highway Told in Jackson Paintings." *Toronto Telegram*, 20 May 1944.

Bridle, Augustus. "War Artists Paint Alaska–B.C. Scene." *Toronto Star*, 29 May 1944.

WORKS MENTIONED
Jackson exhibited 25 oils, including those reserved for the National Gallery of Canada and the following: *Muncho Lake*; *Peace River Bridge*; *Trapper's Shack, Whitehorse*; *Stone Crusher*; *Highway West of Summit*; *Smart River*; *Fort St. John*; *Aurora, Near Nelson*.

1965
Montreal
Walter Klinkhoff Gallery, November, 1965 [*Baffin Island Paintings by A.Y. Jackson*].

1972
Ottawa
Canadian War Museum, National Museum of Man, October 1972–April 1973, *A.Y. Jackson as a War Artist, 1917–1918*. A check list was published. Also shown at the Imperial War Museum, London, summer of 1974.

1981
Lethbridge
Southern Alberta Art Gallery, 5 December 1981–3 January 1982, *A.Y. Jackson in Southern Alberta*. A catalogue by Joan Stebbins was published.

The following reviews are in addition to those listed in the *Exhibitions* section of *A Bibliography of the Group of Seven*.

1948
Dominion Gallery:

François Gagnon, "Paysages du Canada, figures de Byzance." *La Presse* (Montreal), 24 April 1948.

1953
Retrospective:

"Canadian Iconoclast: Retrospective Show at Art Gallery of Toronto." *Art News* 52 (November 1953): 7

"City Gallery 'Expose' Not Unique, says Artist." *Winnipeg Free Press*, 24 March 1954.

"Prairie Painting is Tough says Jackson." *Winnipeg Tribune*, 24 March 1954.

1963
Galerie Dresdnere:

David Cobb, "Canada's Beauty Passes Ugliness on the Rise." *Toronto Star*, 23 March 1963.